IMAGES
of America

GAINESVILLE

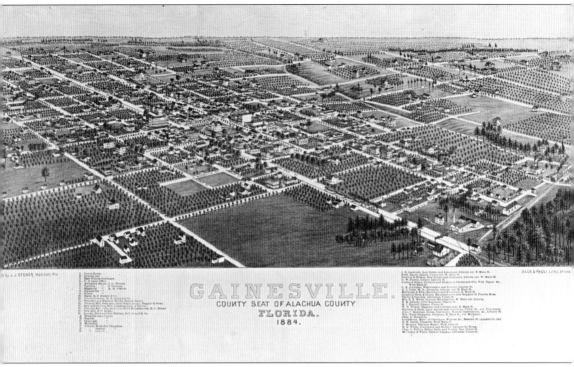

This illustration features an early bird's-eye view of Gainesville. It was published in 1884 by J. J. Stoner, who produced similar views of towns across the country. Gainesville's original courthouse at Courthouse Square is visible in the middle of the print. Several of the town's original street names are also seen upon close inspection. (Courtesy Florida State Archives.)

ON THE COVER: This group of tin can tourists gathered in Gainesville for some kind of police-related gag in the 1920s. The man to the right of the table is Otho Granford Shoup. As the group's leader, he held the title of "Royal Chief." More information about the tin can tourists' role in Gainesville is found on page 63. (Courtesy Florida State Archives.)

IMAGES of America
GAINESVILLE

Rob Hicks in association with the
Alachua County Genealogical Society

ARCADIA
PUBLISHING

Copyright © 2008 by Rob Hicks in association with the Alachua County Genealogical Society
ISBN 978-0-7385-5402-0

Published by Arcadia Publishing
Charleston SC, Chicago IL, Portsmouth NH, San Francisco CA

Printed in the United States of America

Library of Congress Catalog Card Number: 2008920172

For all general information contact Arcadia Publishing at:
Telephone 843-853-2070
Fax 843-853-0044
E-mail sales@arcadiapublishing.com
For customer service and orders:
Toll-Free 1-888-313-2665

Visit us on the Internet at www.arcadiapublishing.com

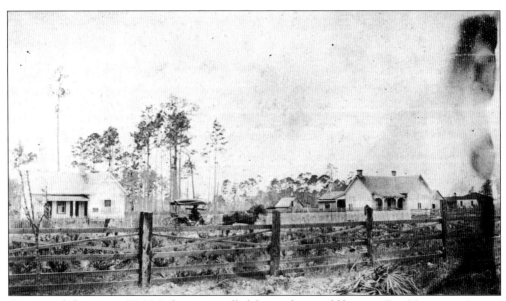

A carriage belonging to W. H. Robertson strolled down what would become East University Avenue when this photograph was taken around 1890. The homes pictured here belonged to James Wyatt (left) and G. B. Crawford. (Courtesy P. K. Yonge Library of Florida History, Department of Special and Area Studies Collections, George A. Smathers Libraries, University of Florida.)

Contents

Acknowledgments 6

Introduction 7

1. Antebellum 9
2. Gainesville Emerges 23
3. The Early Gainesville Community 53
4. Education 89

Bibliography 127

ACKNOWLEDGMENTS

I would like to thank the many individuals who have made this book possible. At the Alachua County Genealogical Society, I would like to thank Mary Singley for her belief and participation in the project. Adam Watson at the Florida State Archives also deserves tremendous credit for the job he does in preservation of the Sunshine State's photographic past. At the University of Florida's P. K. Yonge Library of Florida History, Carl Van Ness and Joyce Dewsbury maintain an amazing collection in one of my favorite rooms in the entire world, which is featured on page 113. They were instrumental in the creation of this book. It would probably be appropriate to thank my professors and friends at the University of Florida for making me love Gainesville and instilling in me the skills to make this work possible. Lastly I would like to thank my wife, Kim. Her patience with me and this project was indefatigable, and Gainesville will always hold special memories for us.

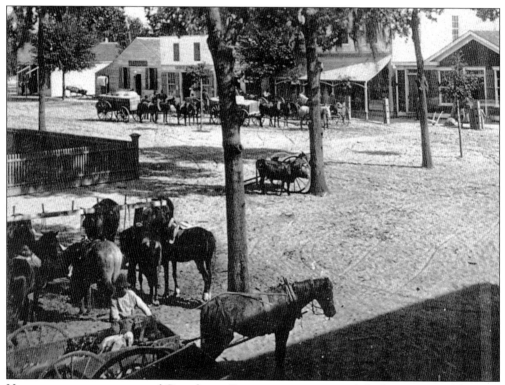

Horse carts congregate around Courthouse Square sometime around the last quarter of the 19th century. This photograph portrays what a typical day in Gainesville looked like during that time. (Courtesy P. K. Yonge Library of Florida History, Department of Special and Area Studies Collections, George A. Smathers Libraries, University of Florida.)

INTRODUCTION

Any discussion of Florida cities with historic relevance is incomplete without including Gainesville. This medium-sized city is best known today as the home of the University of Florida. With over 50,000 students, the school is among the largest in the country, and its goings-on dominate the town. Still, there are other industries in Gainesville. The city seems to be centered almost perfectly between a handful of important Florida locales including Jacksonville, St. Augustine, Orlando, Tampa, and Tallahassee. This fact, the city's connection with Interstate 75, and the influx of talented, youthful, and energetic workers that the university provides have made Gainesville a desirable location for many businesses and residents. However, this city did not grow up overnight, nor was it the university that first brought people here.

The Timucuan Indians first settled the area as many as 5,000 years ago. These people cultivated the land. Their successful attempts at agriculture were a harbinger of many other agricultural activities Gainesville's future would hold. Eventually the Europeans came to Florida in the late 1500s. The French attempted to settle the area around the nearby St. Johns River, but their efforts were crushed by the Spanish. The Spanish took a keen interest in the Florida peninsula. After they claimed the state as their own, they established a cattle ranch called La Chua on Paynes Prairie. Later the Spanish government began extending land grants to their citizens. In December 1817, one such grant that included the area surrounding Gainesville was given to Don Fernando de la Maza Arredondo.

Rather than settle the land himself, Arredondo recruited others to do so as he sold off large tracts of land. However, Spain officially gave control of Florida to the United States in 1821 as part of the Adams-Onis Treaty. A few years later, Alachua County was established. Micanopy and Newnansville emerged as the county's forerunners. Micanopy was home to a popular trading post and Pilgrimage Plantation—a Jewish settlement. Newnansville had the luxury of proximity to Bellamy Road, which connected St. Augustine and Pensacola. In the area that would become Gainesville, a man named Bod Higginbottom is recognized by some accounts as the first white settler. He established his home near what is now Main Street in 1825.

Newnansville and Micanopy remained as the only places of much consequence in Alachua County throughout the first half of the 19th century. They were occasionally affected by skirmishes related to the Seminole Wars, while the area that would become Gainesville stayed extremely rural. In 1845, Florida attained statehood thanks in large part to the work of David Yulee, though he is perhaps better known for his enterprise that ultimately led to the rise of Gainesville. By the early 1850s, Yulee's plans were underway to build a railroad across the peninsula from Fernandina on the east coast to Cedar Key on the west coast. The line's midpoint would lie in Alachua County. This would have ordinarily been an exciting prospect for county citizens, but a problem lay in the fact that little was built in the area through which the train would cross. The few scattered farmers that did live there quickly decided to plat a town and through no small feat were able to convince others to move the county seat there. They named their town Gainesville.

The town grew, but construction on the rails was slow. It was not until March 1, 1861, that the train made its first complete run. Unfortunately, the Civil War began 42 days later. The prosperity the Florida Railroad would offer would have to be postponed. Throughout the war, Gainesville, like most of Florida, was spared as witness to the horrors of large-scale battle. Yet there were some small skirmishes. When Union forces successfully captured Fort Clinch in Fernandina, a portion of the rails was removed to prevent easy entry into Gainesville by Northern forces. After the war, the tracks were rebuilt, and rail service resumed in 1867.

With this, the town prospered. Between 1870 and 1890, the local population doubled. Gainesville was the leading interior city in the state. Much of that growth can be attributed to the African American population. More freed slaves applied for land in Florida under the Homestead Act than in any other Southern state. Many of these were for Alachua County, and the 1870 census

shows more black residents than white in Gainesville. Many African Americans would eventually leave the area, though, as Jim Crow laws were broadened.

Nevertheless, the town saw unprecedented growth through the last half of the 1800s and very early part of the 1900s. That time period is the primary focus of this book. The economy flourished as phosphate, lumber, cotton, citrus, and other crops were taken from the state's interior and sent to Gainesville. From there, they were placed on the train to be further exported from Fernandina or Cedar Key. With Central Florida becoming an important breadbasket, Gainesville became its capital. Many commodities were bought and sold in town. Businesses that supported the surrounding agriculture industry and railroads also sprouted up. As more railroads were constructed, Gainesville became a common stop, which further developed the city's infrastructure and reasserted its prominence.

As the Gainesville population expanded in a new and rural state, a handful of small private schools opened to educate local youth. Some of these schools, like the East Florida Seminary, quickly gained a reputation as quality academic institutions and would eventually receive state funding. As a result, the city itself became somewhat synonymous with the same reputation of quality academics. Thus when the Buckman Act that consolidated the state's post-secondary efforts was passed in 1905, Gainesville was chosen as the home of the University of Florida to serve the white male population. Over time, the school would dominate the social and economic landscape of the city. The significance of the railroads waned, but the school maintained the city's momentum as it grew to become home to one of the largest and best-known universities in America.

Today Gainesville's roots as a railroad depot and agriculture center are buried under its associations with the university. The town claims one of the youngest demographics in the nation as many older businesses and neighborhoods have been converted to or replaced by bars, restaurants, and sprawling apartment complexes. Nevertheless, the city is as proud today to be the home of the University of Florida as it was on the night of July 5, 1905, when bonfires were lit in the street to celebrate the news it had been selected as the university's home. The University of Florida features exceptional athletics, academics, and a world-renowned medical research center and hospital. These represent tremendous sources of pride for Gainesville, as do the other industries the city has attracted. Despite these many changes, Gainesville cannot forget its beginnings. It is a remarkable, if not divergent, history and one that is worth remembering.

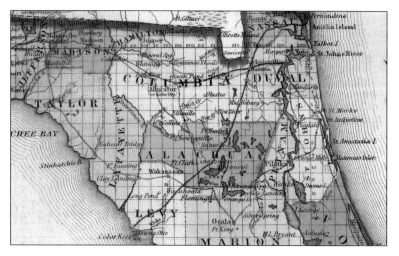

This portion of an 1857 Florida map shows the route David Yulee's Florida Railroad took across the state. (Courtesy P. K. Yonge Library of Florida History, Department of Special and Area Studies Collections, George A. Smathers Libraries, University of Florida.)

One
ANTEBELLUM

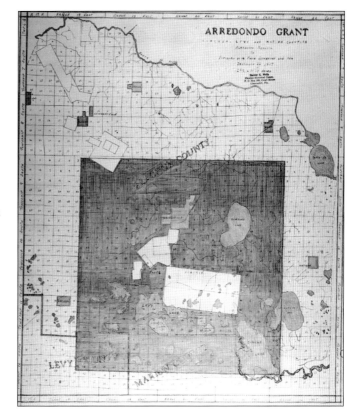

In 1817, Spain ruled Florida and granted many land grants there to those who had been loyal to the crown. Most of what is now Alachua County was given to Don Fernando de la Maza Arredondo, a merchant from Cuba. Arredondo was given nearly 290,000 acres under the condition he settle 200 families there within the next three years. Arredondo never settled the area himself but hired Horatio Dexter and Edward Norton to establish relationships with the Native Americans and promote the area to potential settlers. (Courtesy Florida State Archives.)

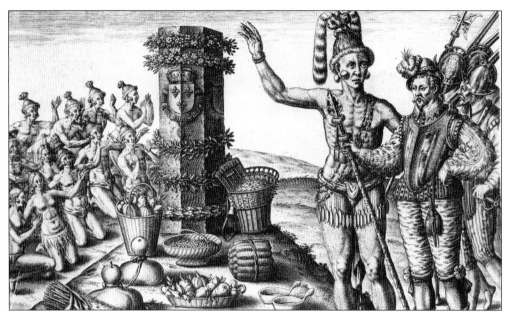

Before Arredondo was granted what is now Gainesville, the area was home to a Timucuan Indian village. Other Timucuans were found throughout North Florida and southeast Georgia. At their peak, they numbered about 50,000 and thrived by eating shellfish and growing corn, beans, pumpkins, and squash. The taller Timucuans covered their bodies in tattoos and wore their hair in unusually high hairstyles, which must have been a sight for the much shorter Spanish explorers they first came in contact with. (Courtesy Florida State Archives.)

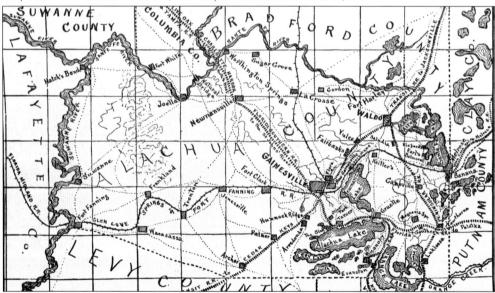

A little over three years after Arredondo was given his grant, Spain was forced to cede Florida to the United States. Later, in 1824, Alachua County was officially created. The county was named from a Native American word meaning "jug" after the sink at Paynes Prairie and included parts of what are now several other counties. Newnansville was chosen as the county seat. This is a map of Alachua County as it appeared in 1883 after the railroads had moved in. (Courtesy Florida State Archives.)

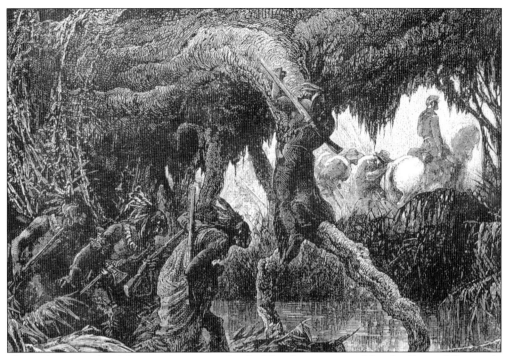

Throughout much of the state's territorial rule, Florida was marred by the Second Seminole War. When the war ended in 1842, more than 1,400 whites had been killed and scores of Native Americans had met the same fate or been forced to flee to the Everglades. Near Gainesville, a brief battle occurred between the Seminole Indians and the Florida Militia near what is now San Felasco Hammock State Preserve on Millhopper Road. An etching depicting a scene from the war is seen here. (Courtesy Florida State Archives.)

By 1845, Florida was granted statehood thanks in large part to this man, Florida senator David Yulee. Yulee's father, Moses Elias Levy, had previously established a Jewish settlement near Micanopy. Yulee desired to build a railroad across the state from Fernandina on the Atlantic Coast to Cedar Key on the Gulf Coast. This would save ships the trouble of sailing around the peninsula as goods could be transported more quickly across the state by train. Yulee's design had the train's central point in Alachua County, an epicenter ripe for economic development, but not near the established county seat of Newnansville. (Courtesy Florida State Archives.)

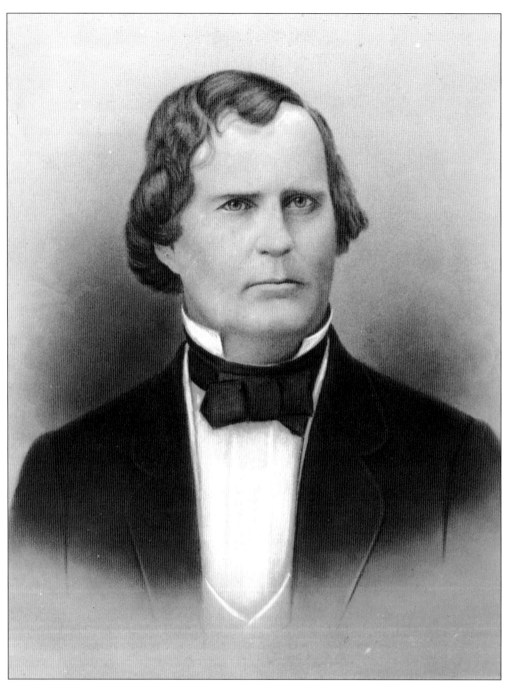

With the prospect of the coming railroad, those already living near the area through which the rails would pass quickly organized in an attempt to plat a town. The real trick came in convincing other county citizens to move the county seat there. Florida governor and Alachua County resident Madison Starke Perry, seen here, supported the move. In 1853, a picnic and election were held at Boulware Springs to decide the new town's fate. Debate was heated, but after contractor Tilman Ingram agreed to build a new courthouse at a surprisingly low cost, the decision was made to move the county seat to the new town. (Courtesy Florida State Archives.)

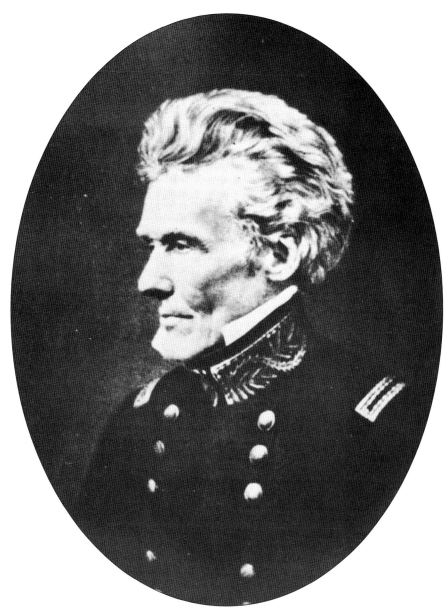

It is generally believed that Gainesville is named after Seminole War hero Gen. Edmund Gaines, seen here. Gaines was also responsible for the capture of famed traitor Aaron Burr. An interesting debate arose over what to name the new town. William Lewis, a well-known and wealthy area planter, suggested the town be named Lewisville after himself. A compromise was struck between Lewis and the Gaines supporters that if the new town were given the county seat, the name would be Gainesville; otherwise Lewis would prevail. While the history of this compromise is clear, the real story behind who put the "Gaines" in Gainesville is not. The leading supporters of the name Gainesville served under the general in the Seminole Wars, which is why he is most commonly referred to as the namesake. However, in 1917, an early Gainesville settler wrote that the name came from the "gained" (winning) vote the eastern Alachua residents received in the Lewis compromise. In fact, the town name was consistently spelled "Gainsville" in various writings until the 1860s. (Courtesy Florida State Archives.)

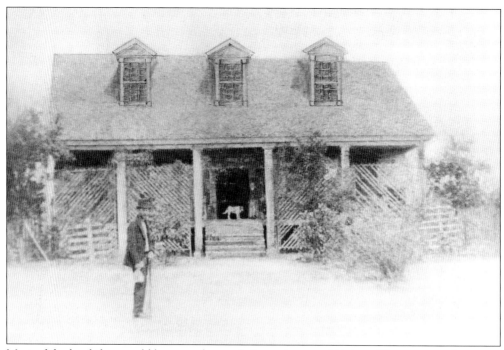

Most of the land that would become the newly formed town of Gainesville was part of a cotton plantation owned by Maj. William Bailey. His home, seen here, was built on what is now Northwest Sixth Street in 1854. It still stands as the oldest house in Gainesville. Bailey was among the strongest advocates of the formation of the town and the "Gaines" name. (Courtesy Florida State Archives.)

Gainesville's first courthouse was a two-story building with entrances that faced each of the four cardinal directions to appease those living on each side. The structure was built for $5,000 and completed on September 15, 1856. The building was poorly ventilated and the grounds were frequented by free-roaming livestock—both points that greatly irritated local judges. (Courtesy Florida State Archives.)

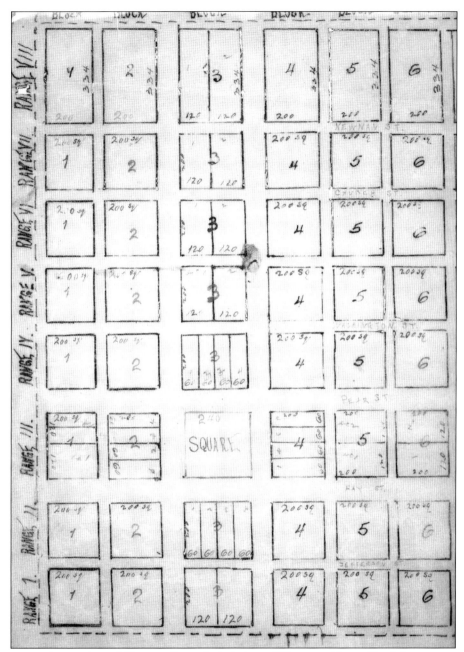

The original township of Gainesville included about 103 acres. About 63 of those originally belonged to Major Bailey. The other 40 were bought by the county commission from Nehemiah Brush. The original plat was roughly bordered by what is now Northeast Fifth Avenue, the creek known as Sweet Water Branch, Southeast Second Place, and Southwest Second Street. The streets bordering Courthouse Square were 90 feet wide, while the other interior streets were 45 feet wide. The land was initially offered at extremely low prices, with rates declining as one moved away from Courthouse Square. A portion of an original Gainesville plat is seen here. (Courtesy P. K. Yonge Library of Florida History, Department of Special and Area Studies Collections, George A. Smathers Libraries, University of Florida.)

Many people often erroneously report the original name of Gainesville as Hogtown. That name was taken from the creek and small settlement near where the intersection of Northwest Thirty-fourth Street and Northwest Eighth Avenue are today. Tilman Ingram, who built the courthouse, had a productive plantation in the area. A band of Seminole Indians also called the area home. This is a photograph of a carriage crossing Hogtown Creek in 1905. (Courtesy Florida State Archives.)

A few miles to the southwest of Hogtown lay the homesite of Thomas Evans Haile and his wife, Esther Serena Chestnut Haile. Serena, pictured here, was the daughter of a prominent South Carolina planter and kept an extensive journal. She bore 16 children. (Courtesy Florida State Archives.)

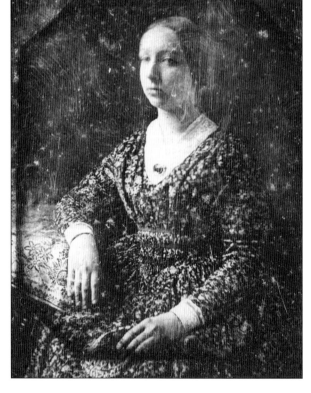

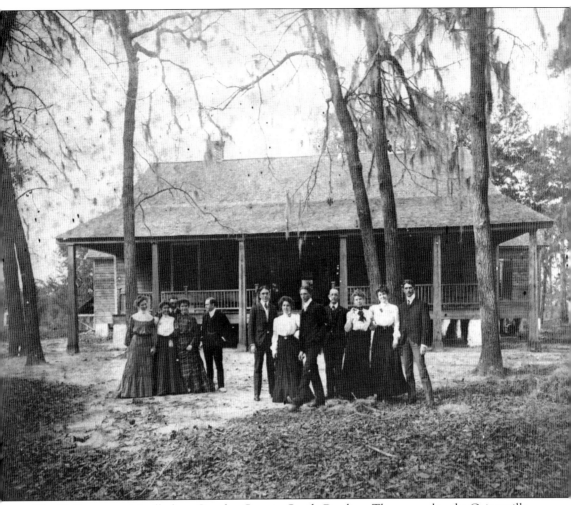

The Hailes were originally from Camden County, South Carolina. They moved to the Gainesville area in 1854 and established a 1,500-acre sea island cotton plantation and the large house in this photograph. They called their settlement Kanapaha. The Hailes had a large family, and when they both died in the early 1890s, they left the Kanapaha property to Evans Haile, their 14th child. Evans went on to become a well-known Gainesville attorney. The family had an unusual habit of writing on the walls, and nearly 12,500 words can still be seen at the house, which is operated as a museum by Historic Haile Homestead, Inc. (Courtesy Florida State Archives.)

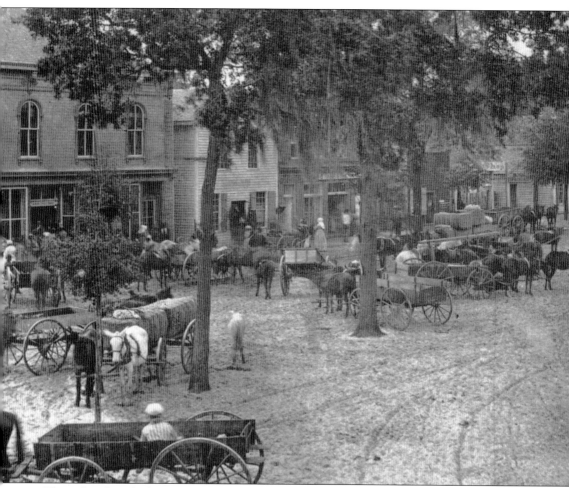

The railroad reached Gainesville in the winter of 1859 and would be completed a short time later. The town began to develop as businesses emerged looking to take advantage of the opportunities the new railroad afforded. Most of the businesses centered around Courthouse Square. The first of these was Ramsey and Ramsey's General Store. Tilman Ingram soon set up a competitor, and a pair of pharmacies also opened their doors. Naturally, construction on houses followed as well as the establishment of a handful of hotels that catered to those who had business with the railroad. This photograph of downtown Gainesville was probably taken sometime in the 1870s and shows what a typical day in the busy town looked liked. (Courtesy P. K. Yonge Library of Florida History, Department of Special and Area Studies Collections, George A. Smathers Libraries, University of Florida.)

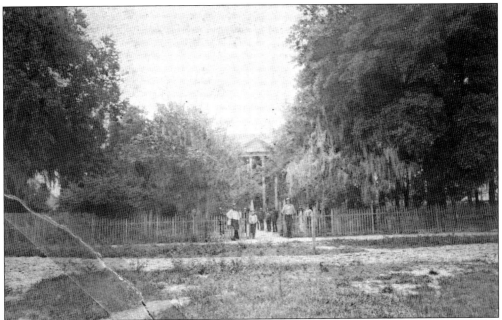

One of the first homes completed in town was Tilman Ingram's magnificent Oak Hall. The home was later moved from its original location on what is now Southeast Second Place to Southeast First Street, where it served as the United States Land Office, seen here. (Courtesy P. K. Yonge Library of Florida History, Department of Special and Area Studies Collections, George A. Smathers Libraries, University of Florida.)

The Turner home sat a little farther outside of town when this photograph was taken. It was located at approximately 2100 Northwest Eighth Court, outside Gainesville's original city limits. Pictured from left to right are B. Wells, Mrs. J. D. Turner, and Mrs. B. Wells. (Courtesy Florida State Archives.)

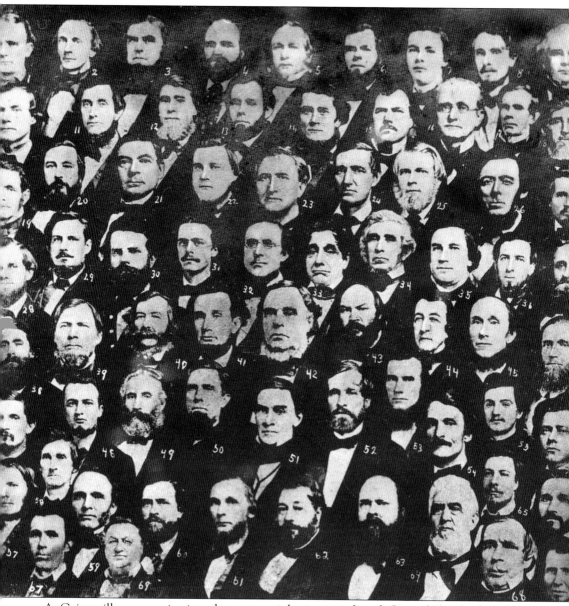

As Gainesville was growing into the commercial epicenter of north Central Florida, the political climate was changing. Most of the white population in Gainesville and Alachua County strongly supported slavery. Gainesville fully depended on the trade of goods produced by surrounding plantations. Moreover, most of the population were either born in or were the children of parents who were born in South Carolina—home of the most adamant pro-slavery supporters. So it was on January 3, 1861, a convention met in Tallahassee to determine Florida's fate in the Union. The delegates of that convention are seen here. Judge James B. Dawkins (No. 66) from Gainesville was one of two delegates from Alachua County; Dr. John C. Pelot (No. 26) from Micanopy was the other. On January 10, the delegates officially chose to secede. (Courtesy Florida State Archives.)

Florida went on to serve as an essential food basket for the South during the war. Gainesville was home to an important food commissary. This is Capt. John Jackson Dickison, who roamed the state defending it against Northern attacks. Dickison was detested by the Union as he was quite successful in minimizing their endeavors within the state. (Courtesy Florida State Archives.)

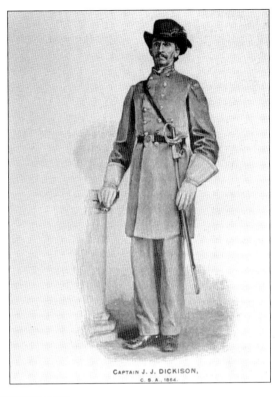

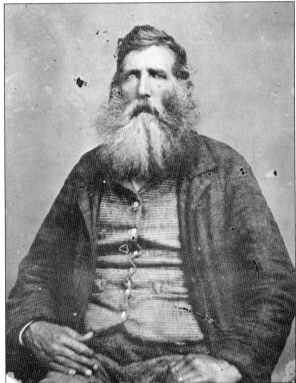

Locally Tilman Ingram and Phillip Benjamin Harvey Dudley (pictured here) established military units from Gainesville's men. Eventually these became part of the 7th Florida Regiment. Dudley's group became Company C, and the men were moved to Gen. Braxton Bragg's command in Tennessee. From there, they took part in several significant battles. (Courtesy Florida State Archives.)

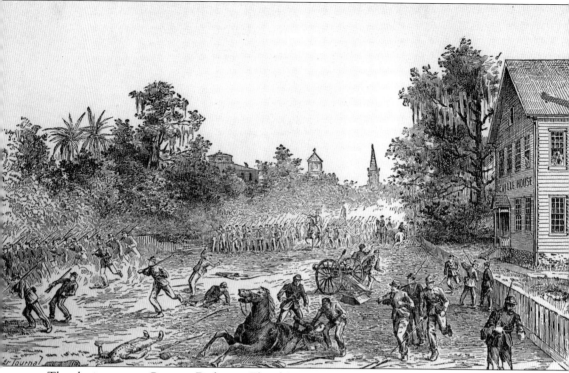

Thanks in part to Captain Dickison, Florida's interior was spared serious damage from war. Gainesville, however, did see two skirmishes. The larger of these took place in front of the Beville House. On August 17, 1864, Union troops arrived in town and fought off a small band of local guards. The commanding Union officer mistakenly assumed his troops had just defeated Dickison and sent his troops off to ransack the town. However, Dickison and his men were not far behind and soon formed an attack. The scattered Union troops were eventually able to better position themselves in front of the Beville House. Ironically that was the very location the women of town had fled to for safety when the fighting began. Nevertheless, Dickison and his men made short work of the Union forces and ended up killing or capturing their majority. No civilians were injured in the affair, and only one of Dickison's men was lost. This is an early rendering of that battle. (Courtesy Florida State Archives.)

Two
GAINESVILLE EMERGES

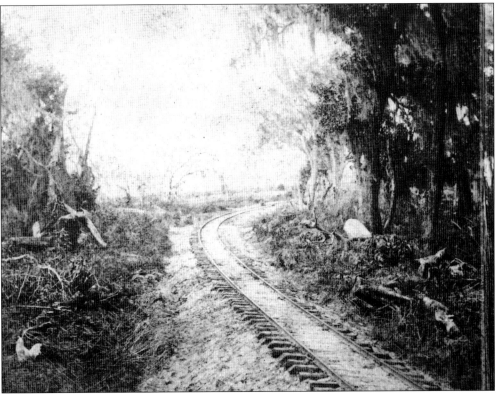

After Fernandina was captured by Union forces, the railroad between the coastal town and Baldwin was destroyed to prevent the Union's quick entry into Gainesville. The line between Baldwin and Gainesville remained open. After the war, the Fernandina connection needed to be reestablished if Gainesville's economy was to push forward. The railroad was finally rebuilt by July 1867, and Gainesville once again emerged as a major Florida trading post. This photograph illustrates a portion of the Florida Southern Railroad Line near Paynes Prairie. Until it was taken over by Henry Plant, this line used a narrower gauge than what had become the standard. (Courtesy Florida State Archives.)

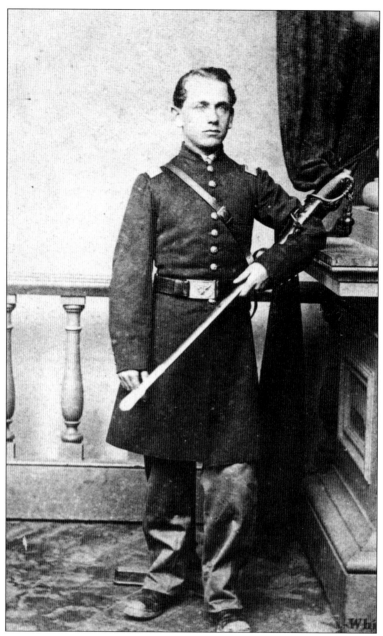

Despite economic growth, postwar Gainesville was not without political unrest. At the center of it all was Union veteran and new Gainesville resident Leonard "Little Giant" Dennis. He quickly became firmly entrenched in the Alachua County Republican Party and went on to serve in the state House of Representatives. However, his political influence was best known by his ability to swing elections. After the war, Alachua County claimed one of the largest black populations in the state and their registered voters out-numbered the whites. Almost all of the black population was aligned with the Republican Party. Thus, Dennis used these numbers with his position in the party to amass a fortune doing nothing less than blatantly selling public offices across the state. Being a shrewd businessman, he always obtained a signed letter of resignation from buyers first in case things went sour. He is pictured here as a young man. (Courtesy Florida State Archives.)

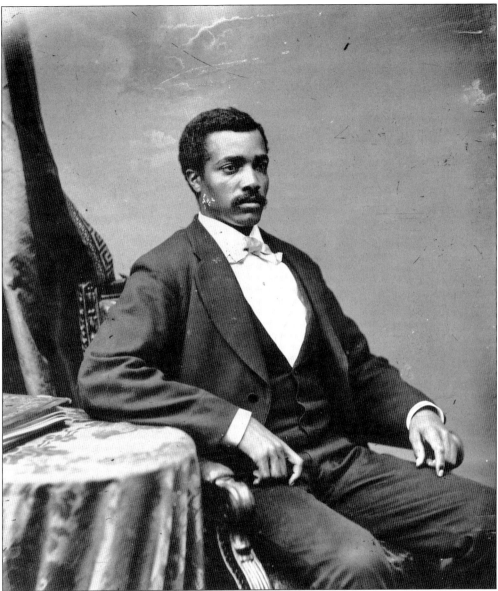

There always seemed to be at least a little friction between the Alachua County Republican Party's white members, headed by Dennis, and its black members headed by Josiah T. Walls, who is seen here. Walls was very well respected by whites and blacks alike in Gainesville and served as mayor for a short period in 1873. He was a strong advocate of black representation in government. Walls served two terms in the U.S. House of Representatives, although he was removed from office both times after his elections were contested by losing members of the Democratic Party who controlled the House of Representatives. (Courtesy Florida State Archives.)

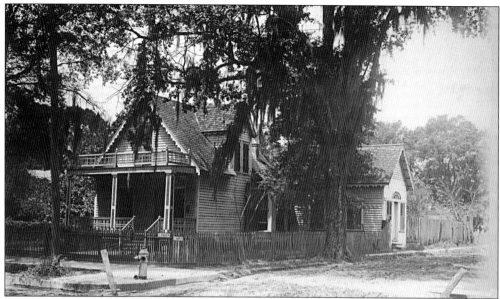

Dennis's home, located at 218 Northeast First Street, was the site of an 1876 presidential election fraud. After the polls closed, the Alachua County voting box was brought here, where Dennis oversaw an additional 219 Republican votes stuffed in the box. Florida was a key state in the election, and the results bolstered a county win by Rutherford B. Hayes. Nevertheless, Samuel Tilden was able to keep the state for the Democrats. (Courtesy P. K. Yonge Library of Florida History, Department of Special and Area Studies Collections, George A. Smathers Libraries, University of Florida.)

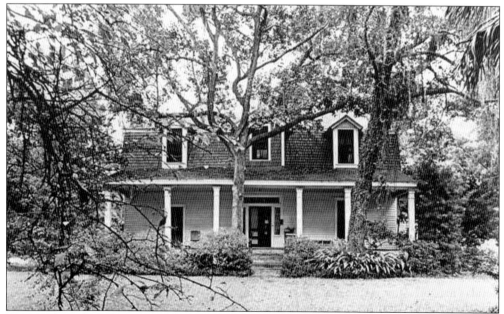

Despite the political turmoil caused by Dennis's improprieties, the town moved along as new construction continued. This is the second-oldest home in Gainesville now. It was built at 528 Southeast First Avenue in 1867 by James Douglas Matheson and is currently in the possession of the Alachua County Historical Society. (Courtesy Florida State Archives.)

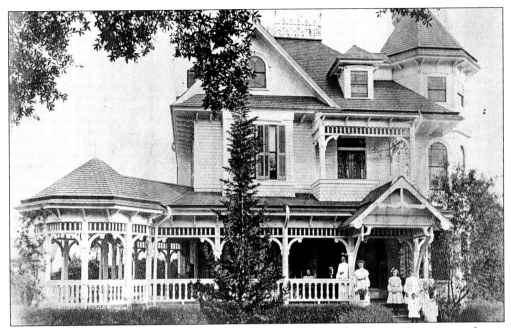

The McKenzie home at 617 East University Avenue is Gainesville's largest Victorian residence. It was built around 1895 and owned by William Turner Pound and his wife, Mary Phifer. After William died, Mary wed Reid Hill McKenzie. The home is now part of the Sweetwater Branch Bed and Breakfast along with the Cushman-Colson House. (Courtesy Florida State Archives.)

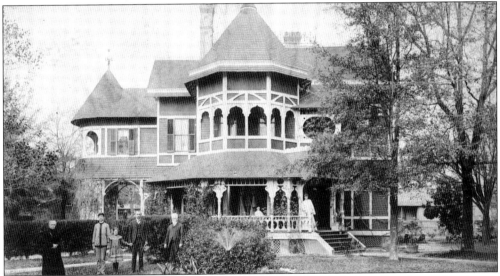

The home of Phillip Miller was located across from the First Methodist Church on what is now Northeast First Street. Miller ran a grocery store and had a hand in naming the University of Florida's mascot. After visiting his son at the University of Virginia, Miller contacted an outfit there that produced pennants and other memorabilia, which he wanted to sell in his store. Since the school did not have an emblem, Miller's son suggested that an alligator would represent Florida well. These pennants represent the first time an alligator appeared in association with the school. (Courtesy P. K. Yonge Library of Florida History, Department of Special and Area Studies Collections, George A. Smathers Libraries, University of Florida.)

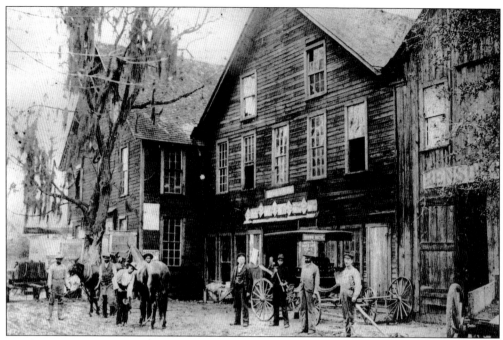

As the South continued to recover, the economy of Gainesville grew larger, and more new businesses were established. This livery and blacksmith shop stood on Southeast First Street in the 1890s. The businesses likely kept busy servicing the town's horses, wagons, and carts. A coach belonging to the Brown House hotel is also seen in the photograph. (Courtesy Florida State Archives.)

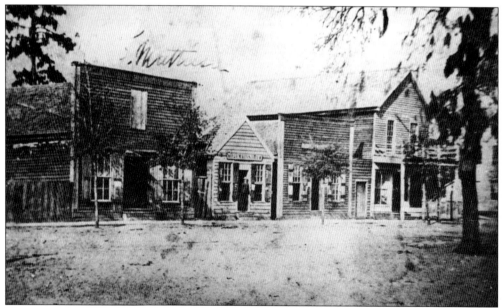

This is another view of some of Gainesville's earliest businesses around 1883. These businesses were on the north side of Courthouse Square. They are, from left to right, James Matheson's mercantile store, the dental office of Dr. James F. McKinstry, and Adolph Vidal's pharmacy. (Courtesy Florida State Archives.)

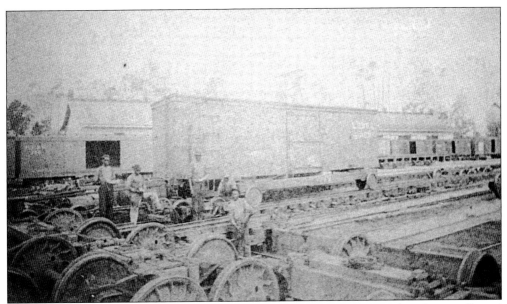

Spurring this growth in business were the crops grown in the areas surrounding Gainesville and shipped around the country via the railroads running in many directions. This local transfer machine was proof of the various railroads running through town, as its purpose was to place standard-gauge cars on narrow tracks. (Courtesy Florida State Archives.)

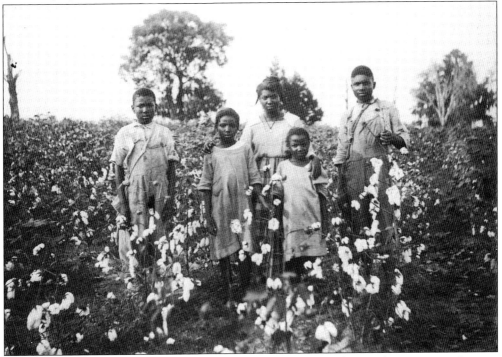

There were many crops grown in the area, but as in much of the South, cotton was king in Gainesville. By 1881, Florida led the country in the production of sea island cotton. Much of this was processed in Gainesville or at least shipped through there. This photograph depicts a family of cotton pickers from Gainesville in 1910. (Courtesy Florida State Archives.)

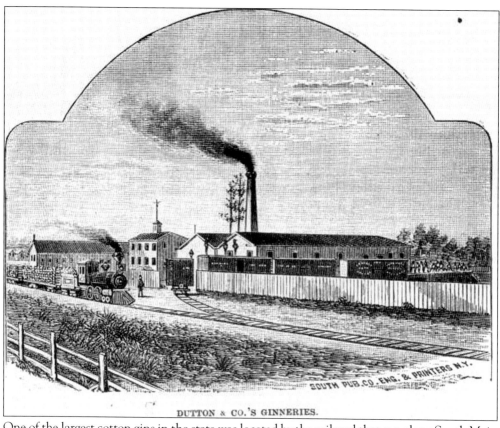

One of the largest cotton gins in the state was located by the railroad that ran along South Main Street. This facility was established by Henry F. Dutton and completed in 1882. It housed 14 gins and could handle 3,000 pounds of cotton a week. The endeavor was so successful that Dutton eventually opened branches in South Carolina and Georgia. (Courtesy Florida State Archives.)

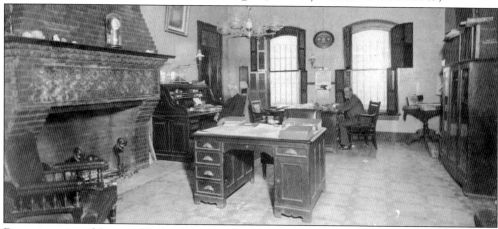

Dutton was one of Gainesville's leading entrepreneurs and established a bank in 1886. The building is still located at 20 West University Avenue. The Masonic Lodge met on the third floor until 1908. This is Dutton in his office (right) with his associate Mr. Nichols (left). (Courtesy P. K. Yonge Library of Florida History, Department of Special and Area Studies Collections, George A. Smathers Libraries, University of Florida.)

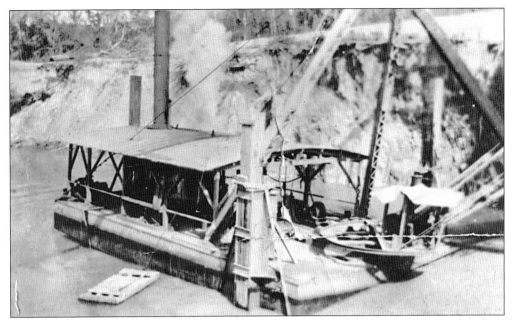

The bank also served as the offices of Dutton's other businesses. In 1890, he established a phosphate company, as the county was rich with the mineral. Gainesville quickly grew into one of the phosphate capitals of the world with Dutton as its leader. This dredge boat was used in Dutton's phosphate mining operations around Gainesville. (Courtesy Florida State Archives.)

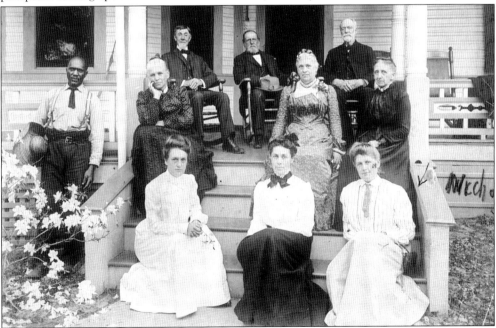

Dutton had his home at the corner of what is now West University Avenue and Southwest Second Street. Dr. Babcock, who partnered with Tilman Ingram to operate a general store, originally built it. This photograph features Henry Dutton in the middle of the third row along with unidentified friends and family. (Courtesy P. K. Yonge Library of Florida History, Department of Special and Area Studies Collections, George A. Smathers Libraries, University of Florida.)

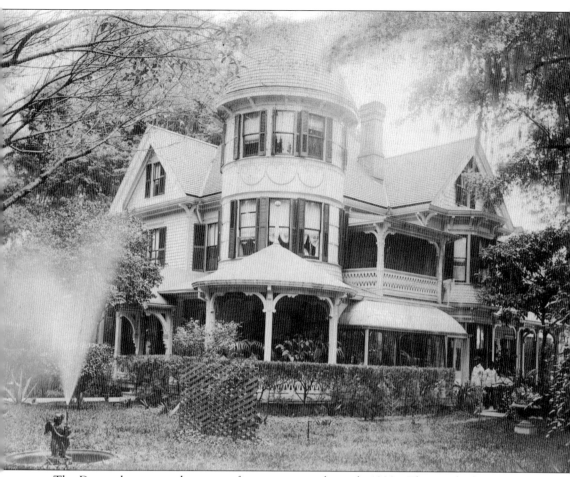

The Dutton home was the scene of quite a stir in the early 1880s. The city had attempted to drill an artesian well in 1882 at Courthouse Square when gold-bearing ore was struck at 176 feet. The drill was eventually moved over to the Dutton home, where the gold was struck again at 190 feet. Harvard University confirmed the presence of gold but determined the ore would yield only $4.16 worth of the metal for every 2,000 pounds of material mined. Thus, the idea of gold riches was abandoned and the vein is still in place under the city. (Courtesy P. K. Yonge Library of Florida History, Department of Special and Area Studies Collections, George A. Smathers Libraries, University of Florida.)

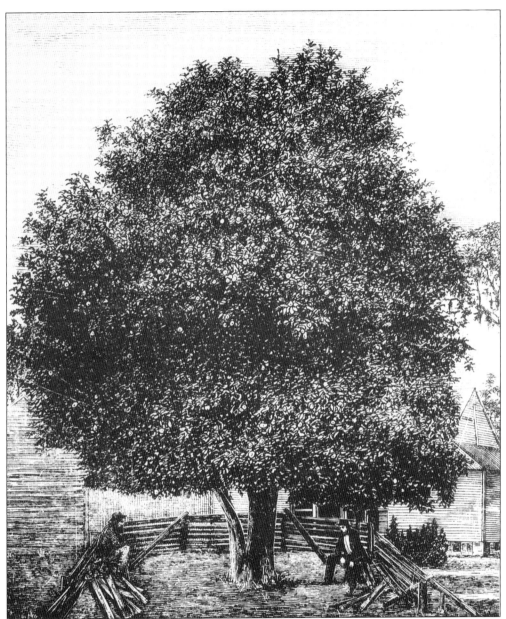

For a time in the late 1800s, oranges were another staple crop in Gainesville. In fact, citizens were so enamored by the potential profits the fruit offered that many residents grew trees wherever they could, such as in their lawns or in Courthouse Square. The citrus industry exploded in Alachua County, but the profits would not last. Severe freezes hit the state in 1886, 1895, and 1899. After the latter, it was finally decided that Gainesville was too far north to be a viable location for large-scale citrus production, and operations moved south. The county was able to claim this orange tree as the largest in the state in the 1880s though. The trunk had a 9-foot circumference and was capable of producing 10,000 oranges in a single season. (Courtesy Florida State Archives.)

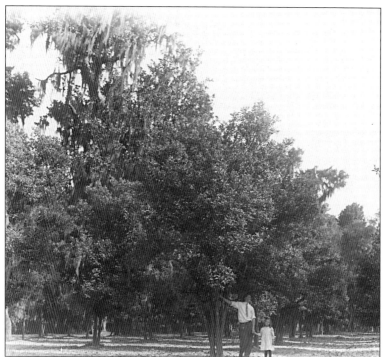

Among the other crops raised in Gainesville were pecans. This photograph taken in the 1910s features the pecan grove of B. F. Hampton, which was located near Gainesville. (Courtesy Florida State Archives.)

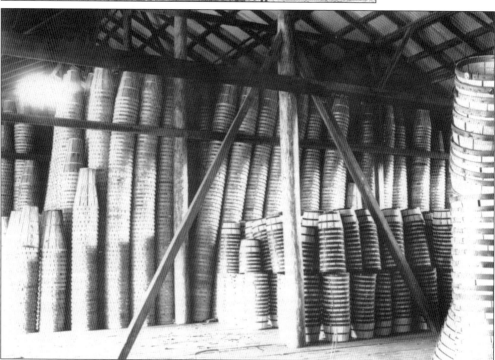

The growth of agricultural operations continued through the early 1900s. Beans, celery, cucumbers, okra, potatoes, pumpkins, melons, strawberries, and tomatoes were just some of the crops grown around the county and shipped from Gainesville. This vegetable hamper factory served the farms surrounding the town in the 1930s. (Courtesy Florida State Archives.)

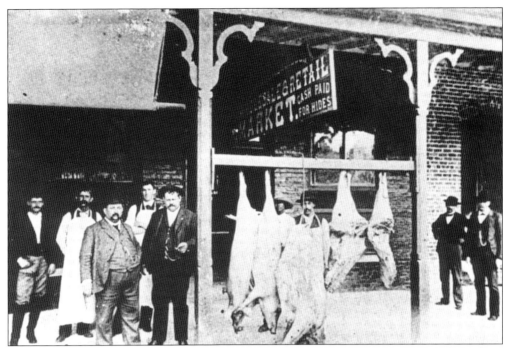

Some of the foodstuffs produced around Gainesville were sold at the markets in town. The Jackson and Richardson Wholesale and Retail Market hung their meat on the curb of what is now Southeast First Avenue. Jackson, Richardson, and a crew of their butchers are seen here, although it is not known who is who. (Courtesy P. K. Yonge Library of Florida History, Department of Special and Area Studies Collections, George A. Smathers Libraries, University of Florida.)

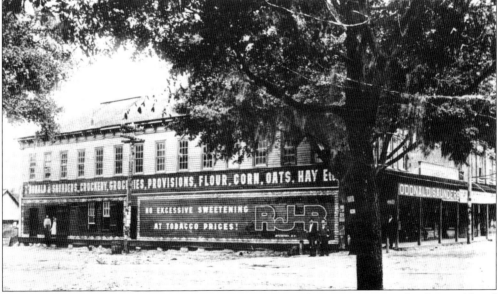

Not far away, at the corner of East University Avenue and First Street, was the O'Donald and Saunders Merchandise store. Edward O'Donald and Minot Saunders purchased the store from Philip Miller and turned it into the largest retailer in Gainesville. In addition to staple groceries, they sold other items such as bicycles and housewares. (Courtesy Florida State Archives.)

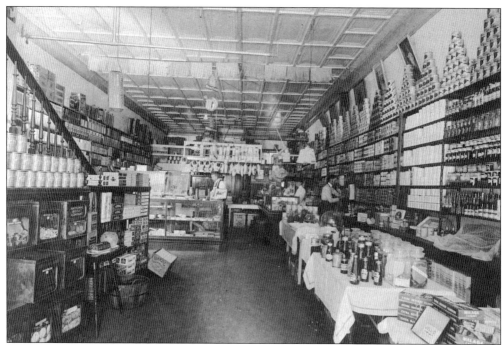

Yet another general store was Dorsey Grocery on the north side of Courthouse Square. Pictured from left to right are William Dorsey, his wife, and an employee. The store's inventory in this photograph included coffee, tea, pineapples, and many canned vegetables. The Dorsey house still stands at 755 East University Avenue. (Courtesy P. K. Yonge Library of Florida History, Department of Special and Area Studies Collections, George A. Smathers Libraries, University of Florida.)

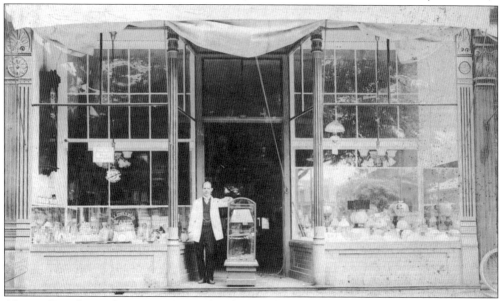

Also at Courthouse Square was Lewis Smith's Jewelry Store. Smith and his store are pictured with signs on the window that advertised Waterman's Ideal fountain pen. (Courtesy P. K. Yonge Library of Florida History, Department of Special and Area Studies Collections, George A. Smathers Libraries, University of Florida.)

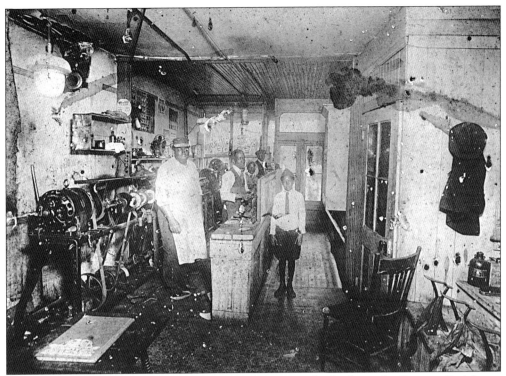
The Duval Shoe Hospital was operated by Charles W. Duval, a leader in the Gainesville African American community. His shoe repair business was located near where the Alachua County Courthouse is today. (Courtesy Florida State Archives.)

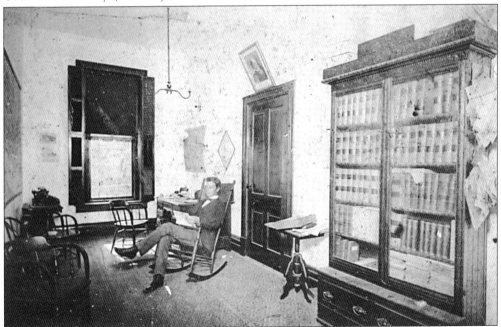
John Ammons was a leading attorney in Gainesville who lived at Northeast First Street and Northeast First Avenue. He is posed here in his office. (Courtesy Florida State Archives.)

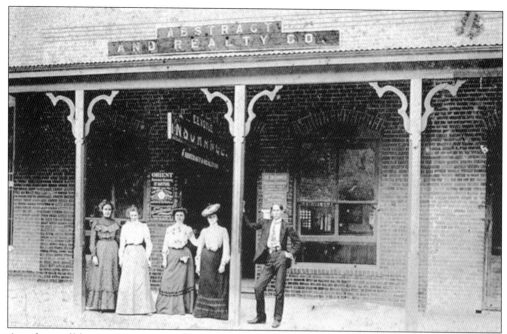

Another well-known attorney in Gainesville was E. E. Voyle. In addition to his law practice, he operated this insurance, abstract, and realty company. This photograph was probably taken in the 1880s. Voyle is on the right; the women are unidentified. (Courtesy Florida State Archives.)

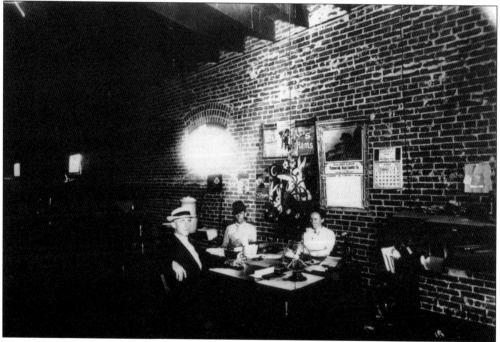

This is Cicero Addison Pound (left) in his office at Baird Hardware in 1913. The other people are unidentified. Pound began working for the company as a teenager and would eventually become the company's president. He also donated the land for the present Gainesville High School. (Courtesy Florida State Archives.)

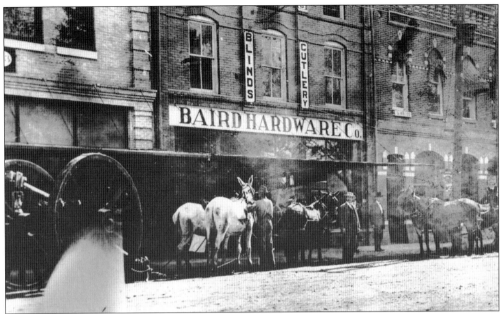

Baird Hardware was established in 1890 by Eberle Baird. By 1900, it was the largest hardware store in the state. The business started in the building in the upper photograph, which was located on the east side of Courthouse Square. However, by 1910, expansion was inevitable and Baird purchased the building to his north. The lower photograph is of the store's interior in the 1920s. In addition to hardware, the store sold appliances and sporting goods. (Courtesy Florida State Archives.)

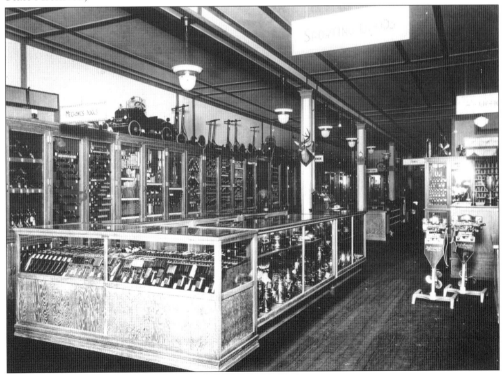

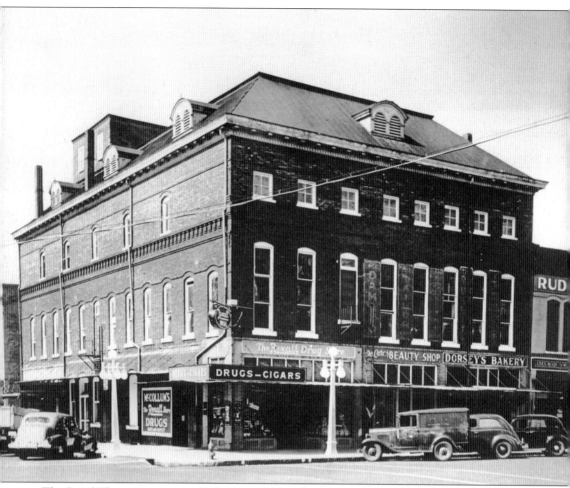

The Baird Theater was originally built in 1887 as the Simonson Opera House at what is now 19 Southeast First Avenue. In 1906, Eberle Baird purchased the building and added a third story. He also added additional seating. Besides live entertainment and operas, Baird's theater featured movies. The business did not fare well during the Depression of the 1930s. When the economy picked up, the Cox Furniture Company, Dorsey's Bakery, and the McCollum Drug Store moved in. It is currently occupied by several restaurants and offices. (Courtesy Florida State Archives.)

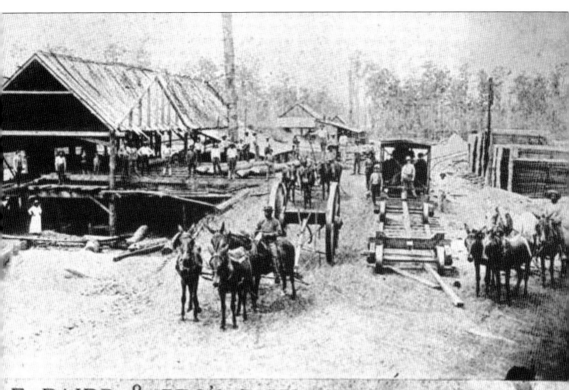

Eberle Baird first came to Florida in 1881 with his brother Emmett, and the two established the saw and planing mill in Hague seen here. Eberle moved to Gainesville first to start his many enterprises. Emmett eventually followed his brother to Gainesville and opened a vegetable basket factory. Legend has it that Emmett befriended a dying man who told him the whereabouts of the lost treasure of the pirate Jean Lafitte near the Suwannee River. After three months of searching, Emmett announced he was giving up and publicly abandoned the endeavor. However, Emmett soon began investing heavily in Gainesville businesses, including his brother's hardware store. This led many to believe he had indeed found the treasure. He supposedly buried the treasure in his house at 309 Southeast Seventh Street before he died in the 1920s. The house has since undergone an extensive restoration, but no treasure has been found. (Courtesy Florida State Archives.)

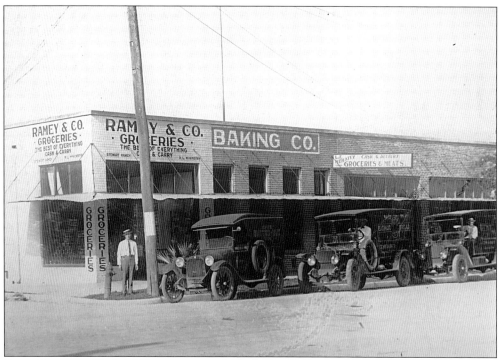

Stuart Ramey and R. L. McKinstry operated this grocery at the corner of West University Avenue and Southwest Sixth Street. A bakery was also located here, and the Eatmor Bread truck that delivered bread all over town can be seen in front of the store. L. F. Mehaffey's grocery store was located next door. (Courtesy Florida State Archives.)

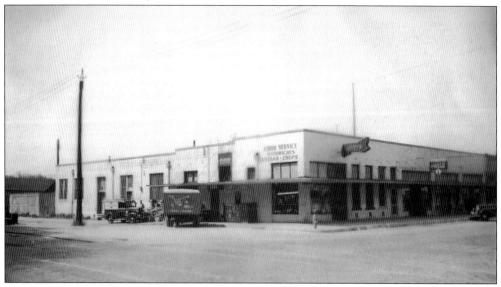

A few years later, the same building that housed Ramey and McKinstry's grocery was home to Jerry's Sandwich Shop. Mehaffey's store became University Grocery. A sign here indicates the Eatmor Bread Bakery became the Bell Bread Bakery. A truck delivering Jax Beer is also seen here. (Courtesy P. K. Yonge Library of Florida History, Department of Special and Area Studies Collections, George A. Smathers Libraries, University of Florida.)

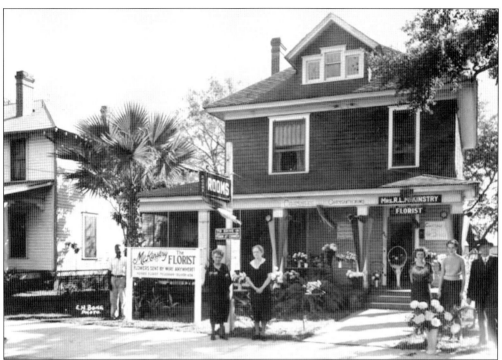

R. L. McKinstry's wife operated a local florist. She catered to University of Florida students. A sign near her door advertises corsages for the homecoming dance. Another sign states she can send flowers anywhere by wire. (Courtesy Elmer Harvey Bone Photographic Collection, University Archives, Department of Special and Area Studies Collections, George A. Smathers Libraries, University of Florida.)

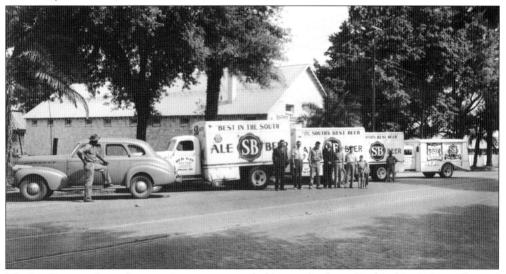

The Jax Beer truck on the opposite page was probably not the first of its kind in Gainesville, and it was certainly not the last. These SB Beer trucks are lined up on a local street. SB Beer was brewed by the Southern Brewing Company in Tampa. (Courtesy P. K. Yonge Library of Florida History, Department of Special and Area Studies Collections, George A. Smathers Libraries, University of Florida.)

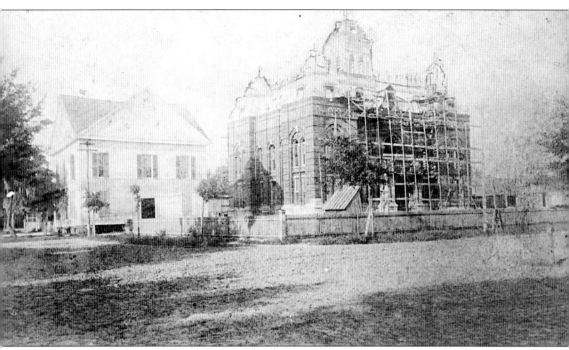

As the local economy surged, the need for new municipal facilities was evident. The aging courthouse was deteriorating rapidly. The roof leaked, the windows were broken, the plaster was falling off the walls, and the building had a serious mold problem. Gainesville residents debated selling Courthouse Square to pay for a new courthouse but decided to build the new courthouse at the same location. This picture was taken in 1885 as the new courthouse was being constructed next to the old one. (Courtesy P. K. Yonge Library of Florida History, Department of Special and Area Studies Collections, George A. Smathers Libraries, University of Florida.)

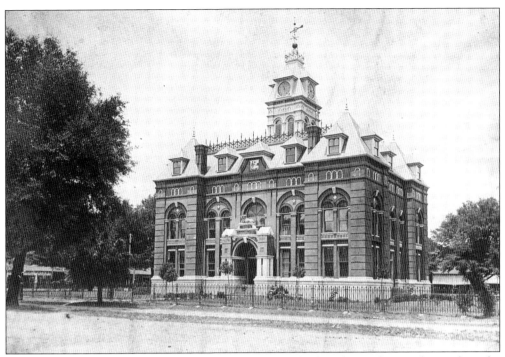

The second Alachua County Courthouse was originally built with a sculpture of an eagle at the top, but that was replaced by a weather vane when the roof was replaced to fix a leak. The fence seen in this photograph from the 1890s was also added after the original construction to keep free-roaming livestock from grazing on the lawn. (Courtesy Florida State Archives.)

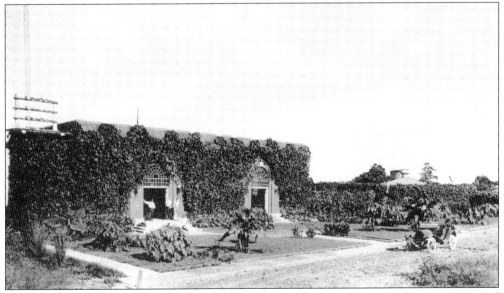

The Gainesville Electric and Gas Company began as a private venture in 1887 and provided power to homes and businesses as well as a few streetlights. In 1911, the city sued the company over a disputed bill. The suit ultimately resulted in the city's purchase of the plant. The power plant in this photograph was constructed by the city and completed in 1914. (Courtesy Florida State Archives.)

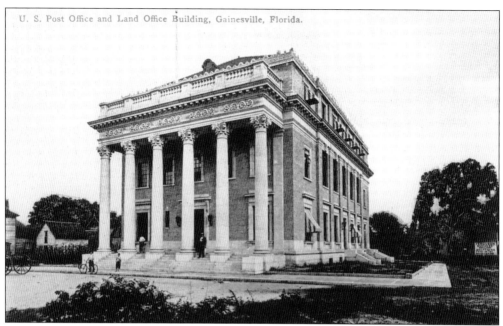

As the population increased, so did the postal load. This impressive building was completed in 1911. The first floor served as the post office, the second floor was a federal courthouse, and the third floor was home to the U.S. Land Office, which had relocated from Tilman Ingram's Oak Hall. It was briefly the home of Santa Fe Junior College in the late 1960s and is now home to the Hippodrome State Theater. (Courtesy Florida State Archives.)

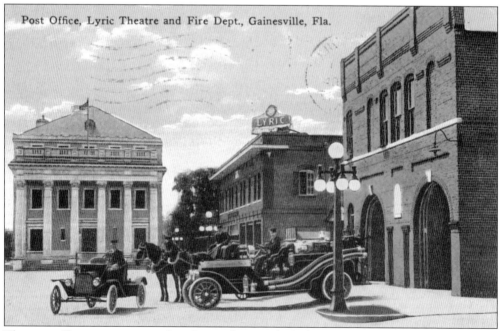

The post office was constructed at the southern end of what is now Southeast First Street on Southeast Second Place. It was adjacent to the 250-seat Lyric Theatre and the Gainesville Fire Station. (Courtesy Florida State Archives.)

Gainesville's first fire engine was donated by Leonard Dennis. It required 15 to 20 men pumping on either side to produce a steady stream and offered five lengths of hose. The horses used to pull the engine were named John, Mac, and Arthur after John MacArthur, an early fire chief. (Courtesy Florida State Archives.)

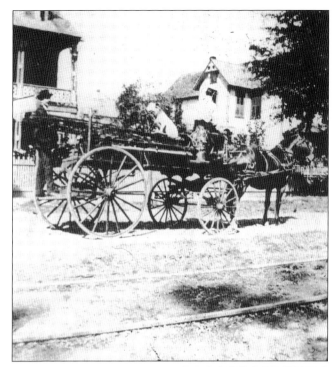

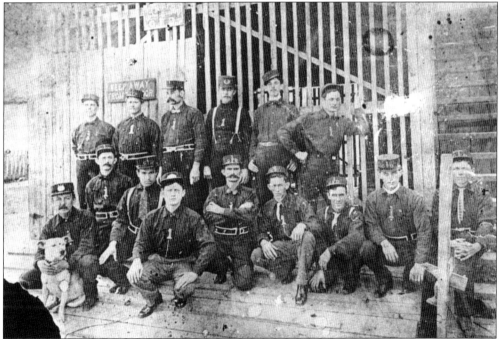

The Gainesville volunteer fire department was established in 1882. These are the members of the department posed sometime in the 1890s. The members seen here from left to right are (kneeling) Nell Benson, E. Kinard, Nick George, John Black, Edward Kinard, Henry Aherns, Herman Taylor, and two unidentified; (standing) G. Owens, C. Pinkoson, John Bennett, Jim Moyer, Claude Divernon, and Frank LaFontisse. (Courtesy Florida State Archives.)

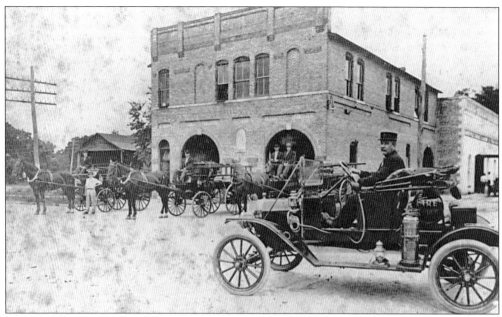

This firehouse was built in 1903 on Southeast First Street. The city council and municipal court met here until 1927. In 1912, the city purchased its first piece of motorized fire equipment for $600. This building was removed in the 1960s in order to widen Southeast Second Avenue. (Courtesy Florida State Archives.)

The police services were not quite as well outfitted. Fights, robbery, and murder were fairly common occurrences in the late 1800s and early 1900s. Those problems were abated somewhat by the election of Lewis Washington Fennell to the position of sheriff. Fennell also served as a county commissioner and on the state Democratic Committee. (Courtesy Florida State Archives.)

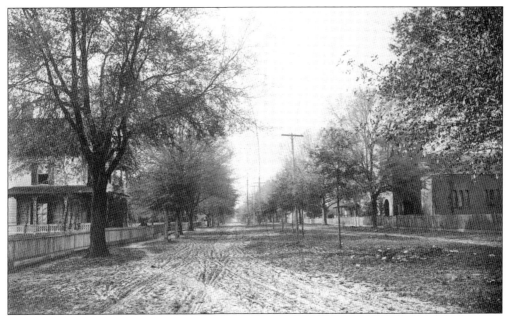

The streets of Gainesville also struggled to keep up with the demands of an increased population. Most streets were surfaced with sand. The steady traffic of horses and carts created holes and ruts that were difficult to navigate. In especially wet conditions, the roads turned to mush. When conditions were dry, dust from the roads covered nearby buildings. This picture illustrates the sand road that ran along Northeast First Street by St. Patrick's Catholic Church. (Courtesy P. K. Yonge Library of Florida History. Department of Special and Area Studies Collections, George A. Smathers Libraries, University of Florida.)

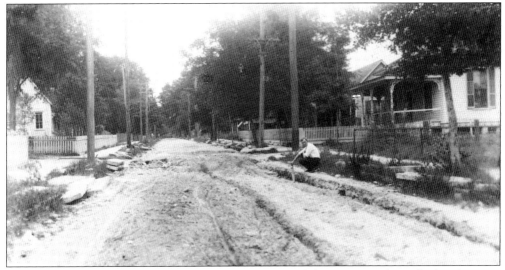

The Florida Southern Railroad agreed to cover some of the streets with crushed rock over a clay base, which helped alleviate some of the problems caused by the sand. In the 1920s, the prominence of the automobile required the streets of Gainesville to finally be paved. This is a view of Northeast Second Street shortly before it was paved. (Courtesy P. K. Yonge Library of Florida History, Department of Special and Area Studies Collections, George A. Smathers Libraries, University of Florida.)

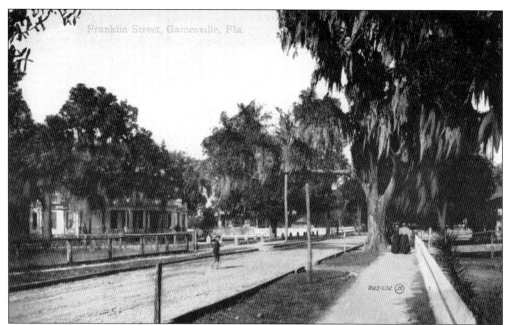

On July 1, 1950, the City of Gainesville implemented a law that renamed all the streets using a numbered quadrant system. Prior to that, the streets were generally named after people, places, and things. Thus postcards like this one that were printed before 1950 identified streets with their earlier names. Franklin Street became Northeast Sixth Street. (Courtesy Florida State Archives.)

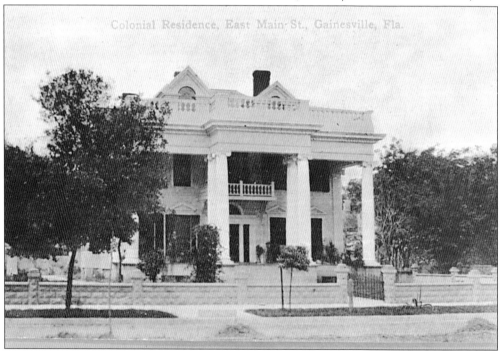

This postcard identifies this home as being located on East Main Street. When the name changed, the home was located on Northeast First Street. This impressive home belonged to Eberle Baird but was razed in 1974. (Courtesy Florida State Archives.)

This home originally stood on Factory Street before the name was changed to Northeast Third Street. It was built in 1899 and would eventually become known as the Blanding House after Gen. Albert Blanding, who attended school in Gainesville in the 1920s. Blanding served as head of the National Guard and played a key role in preserving the Everglades. Camp Blanding, the military installation near Jacksonville, is named in his honor. (Courtesy P. K. Yonge Library of Florida History, Department of Special and Area Studies Collections, George A. Smathers Libraries, University of Florida.)

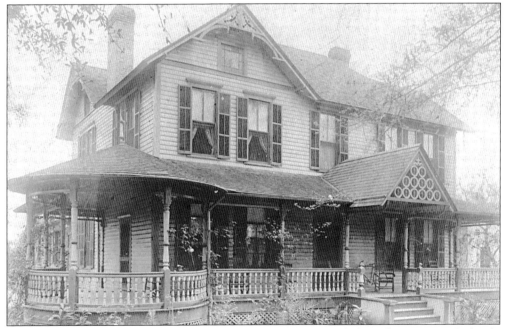

Just down the road from the Blanding House sits this house that once belonged to Benjamin Richards. He worked at a local bank and also owned a pecan grove. The house still stands and is known for its abundance of turned wood. (Courtesy P. K. Yonge Library of Florida History, Department of Special and Area Studies Collections, George A. Smathers Libraries, University of Florida.)

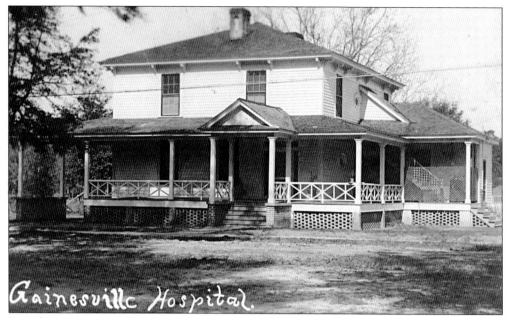

Gainesville Hospital.

For a long time, a handful of hospitals in Gainesville operated as private facilities that offered limited services. While some were capable of performing very minor operations, they were in reality nothing more than convalescent homes. Pictured is one of those homes known as the Gainesville Hospital. (Courtesy P. K. Yonge Library of Florida History, Department of Special and Area Studies Collections, George A. Smathers Libraries, University of Florida.)

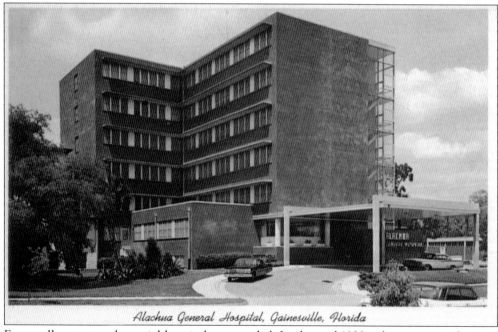

Alachua General Hospital, Gainesville, Florida

Eventually a more substantial hospital was needed. In the mid-1920s, the county and city of Gainesville floated bonds to fund the construction of a hospital with new equipment. The result was Alachua General Hospital located at 801 Southwest Second Avenue. The original building was modified by the time this postcard was produced. (Courtesy Florida State Archives.)

Three
THE EARLY GAINESVILLE COMMUNITY

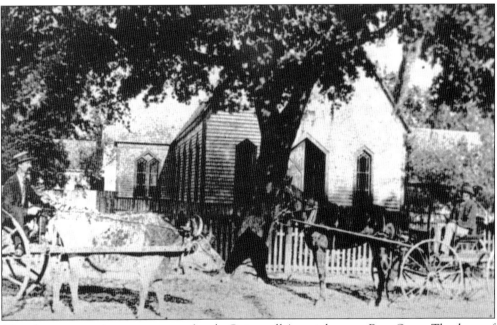

Churches were an important part of early Gainesville's social scene. Rev. Owen Thackara of Fernandina started the first Episcopal mission in Gainesville in 1860. This was their first church building constructed in 1873. It was located at 215 North Main Street where the Masonic Temple is now. The building was used until 1907, when Holy Trinity Episcopal Church opened for services. That church was mostly destroyed by fire in 1991. Luckily the original windows had been removed for repair at the time. They were installed in a new and nearly identical church completed in 1995. (Courtesy P. K. Yonge Library of Florida History, Department of Special and Area Studies Collections, George A. Smathers Libraries, University of Florida.)

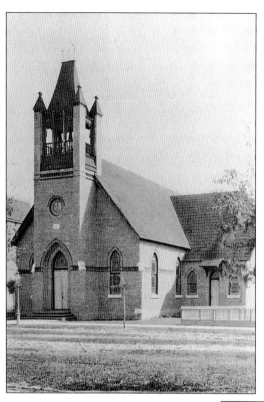

Methodist services were conducted in this building until 1942. It was built in 1886 and was known as the Kavanaugh Memorial Church. The church represented a portion of Gainesville's Methodist society that began in the 1850s. This church was later joined with Epworth Hall, which had been part of the East Florida Seminary. (Courtesy Florida State Archives.)

This was the First Presbyterian Church from 1890 to 1954. Their roots in the county also began in 1850s. In the Gainesville area, this church was preceded by the Kanapaha Presbyterian Church, which was founded in 1859. Once Gainesville began to grow, a shared church building was constructed on Southeast First Street that was used by several denominations, including the Presbyterians. This building signified the Presbyterians' continued growth, as they needed their own chapel. It was located at 234 West University Avenue. (Courtesy Florida State Archives.)

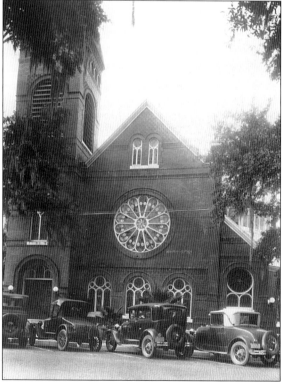

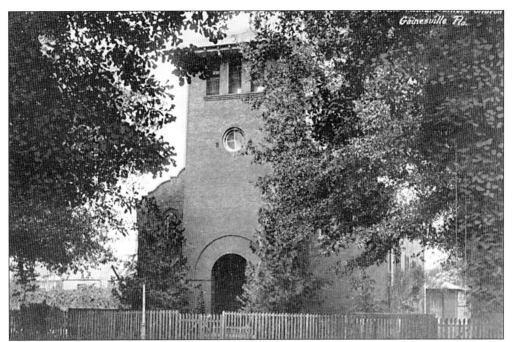

St. Patrick's Catholic Church was built in 1887—twenty-five years after Gainesville's Catholics first started meeting in private homes. They also met for a brief time in city hall. This church was located on Northeast First Street. It was replaced in 1976. (Courtesy Florida State Archives.)

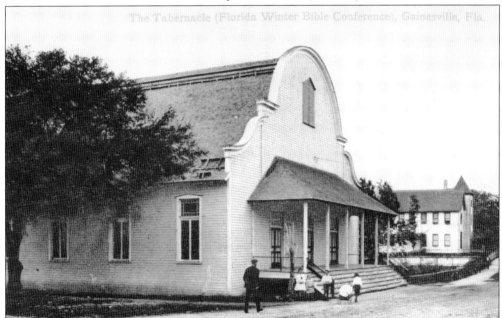

While not really a church, this building was known as the Tabernacle and had some religious ties. It was built in 1906 with a capacity of 2,000 for the annual gathering of the Florida Winter Bible Conference. The city took possession of the building in 1911 and offered it as a meeting place for groups and clubs. The city gave the building to the American Legion in 1926 shortly before it burned down. (Courtesy Florida State Archives.)

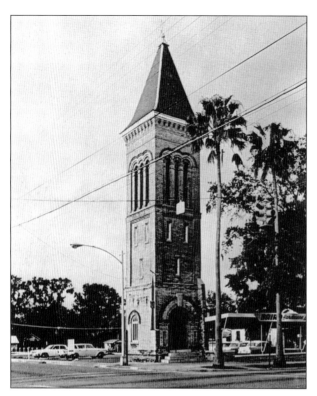

This tower was built as part of the second incarnation of Gainesville's First Baptist Church. Its predecessor was completed in 1875. The building this tower belonged to was located at University Avenue and Northeast Second Street. It held its first service on April 3, 1897. After the congregation's third sanctuary that still stands at 425 West University Avenue was completed, the second building was sold to First Christian Church. It was later acquired by Cicero Addison Pound, the aforementioned Baird Hardware president. (Courtesy Florida State Archives.)

Pound tore down the main church building but left the tower standing. The landmark lent its name to the Tower Parking Lot and the Tower Restaurant. The property was also used to showcase Baird's inventory of boats. This picture was taken as the tower was demolished in 1965 to make room for a new city hall and library. (Courtesy Florida State Archives.)

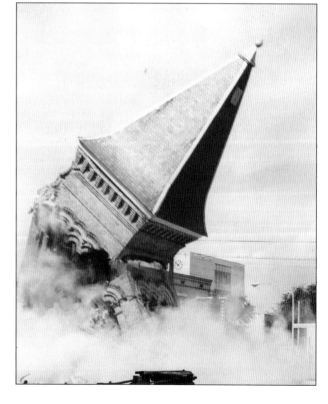

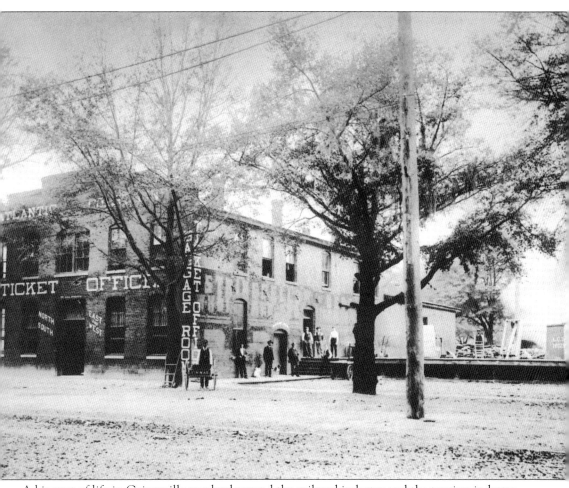

A big part of life in Gainesville revolved around the railroad industry and the tourism industry by extension. This building was the ticket office for the Atlantic Coast Railroad. It was located at 104 North Main Street. The street had formerly been known as West Main Street and had the Atlantic Coast tracks running right down the middle of it. The tracks were removed in 1948, and this office was closed. The First National Bank took over the structure, which was razed in 1954. (Courtesy Florida State Archives.)

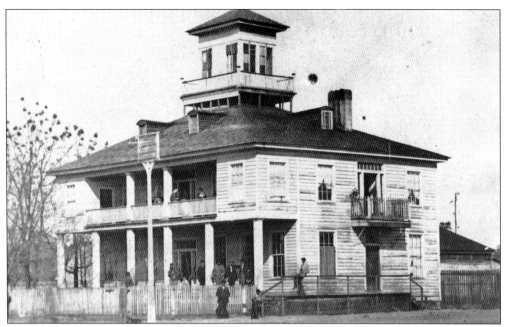

Tourists came to Gainesville regularly in the late 1800s and early 1900s. Railroad mileage in the state nearly quadrupled during this time period, and Gainesville's central location was a stop for many of the new lines. The city became one of the primary railroad hubs in the state and the South. Scores of passenger transfers were made here. As a result, these visitors often needed a place to stay, and several hotels emerged. The building above was known as the Exchange House when this photograph was taken in 1868. It was later known as the Gainesville Hotel. The building below was the Magnolia Hotel. (Courtesy Florida State Archives.)

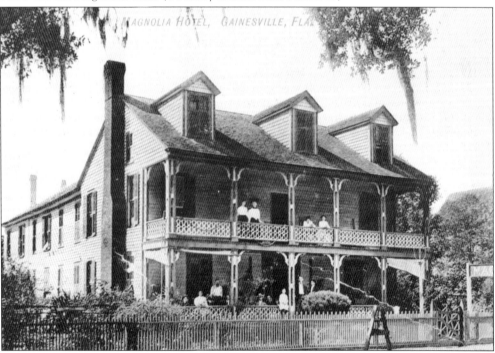

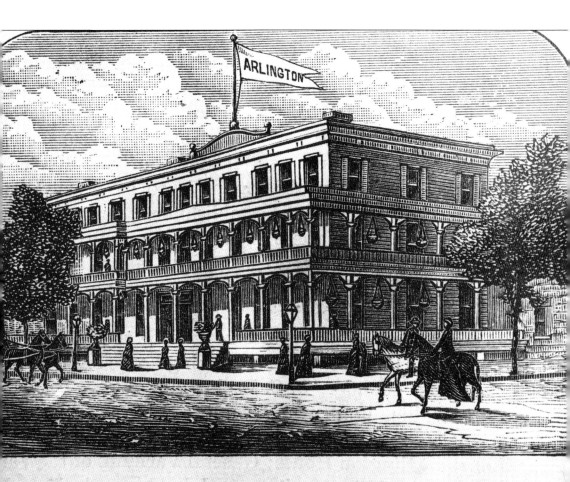

THE ARLINGTON HOUSE, GAINESVILLE.

Perhaps Gainesville's finest hotel before 1900 was the Arlington Hotel. This wooden structure could accommodate 200 guests and was located at the northwest corner of University Avenue and Main Street. For a brief time, it was operated by Leonard Dennis. In May 1884, someone began an arson spree in Gainesville, and four separate fires were set in a single day. One of these was at the Arlington Hotel, and the building was destroyed. The Arlington's competitor, the Varnum Hotel, was also destroyed. Brick became the construction material of choice throughout Gainesville after this. (Courtesy Florida State Archives.)

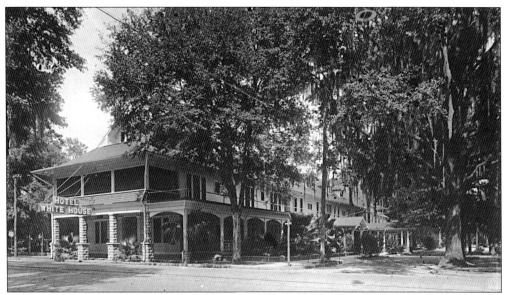

Taking the place of the Arlington Hotel as Gainesville's most upscale hostelry was the White House Hotel. It was originally built as a girls' dormitory for the East Florida Seminary before Maj. William Thomas converted it to the hotel that catered to the Atlantic Coast Line customers. It was perhaps best known for its fine dining. Regrettably it was demolished in 1962. (Courtesy P. K. Yonge Library of Florida History, Department of Special and Area Studies Collections, George A. Smathers Libraries, University of Florida.)

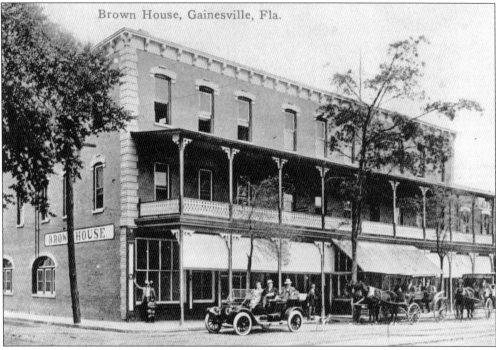

The Brown House also looked to serve the Atlantic Coast Line customers and was located across the street from the ticket office. The building still stands, although the veranda has been removed. It is home to the public defender's office and a restaurant. (Courtesy Florida State Archives.)

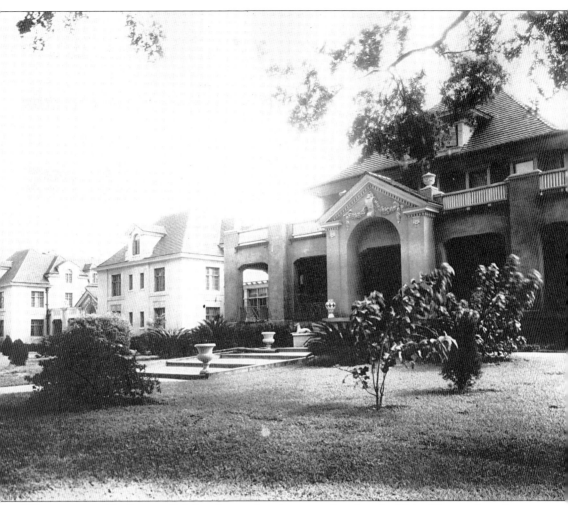

What was arguably Gainesville's best-known hotel was another foray by Major Thomas into the hotel business. The Hotel Thomas began as a private residence known as Sunkist Villa built in 1906 for Charles Chase, manager of the Dutton Phosphate Company. The home remained unfinished when Chase died in 1909. Thomas completed the home and moved his family there the following year. (Courtesy Florida State Archives.)

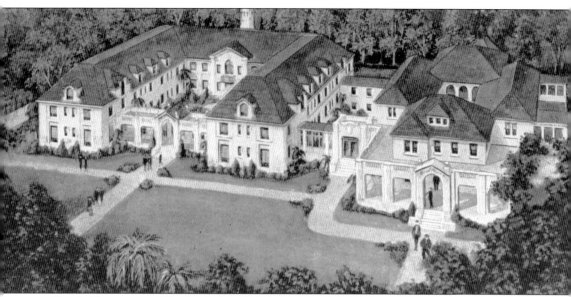

His children grown, Thomas expanded the property to create the hotel. The grand opening was held on January 10, 1928. It featured a miniature golf course, tennis courts, and expansive gardens. The facility was quickly regarded as one of the finest hotels in the state. For a while in the 1960s, the property was home to Santa Fe Community College while the present campus was built. When the structures began to fail in the early 1970s, Historic Gainesville, Inc., was formed and convinced the city to purchase the property. Today it is now known as the Thomas Center and is used as city offices and a cultural center. (Courtesy Florida State Archives.)

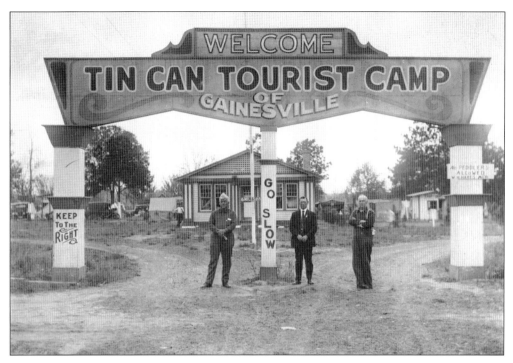

Other visitors to Gainesville might have been content with less luxurious accommodations. Many of those stayed at the Tin Can Tourist Camp. It was located near where the Alachua General Hospital was built later. The camp opened in the 1920s as part of the Dixie Highway that stretched from Michigan to Miami. Tin can tourists were road travelers who used the highway to visit the South. They stopped at these camps along the way and camped out of their cars. Some of the tourists went so far as to permanently attach tin cans to the radiator caps of their cars. (Courtesy Florida State Archives.)

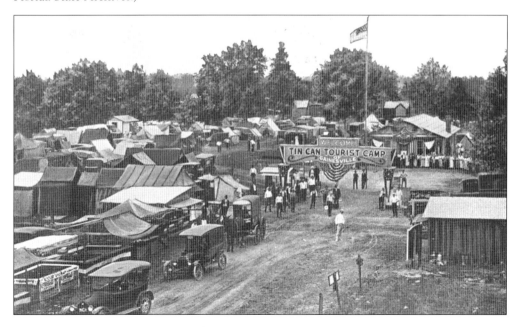

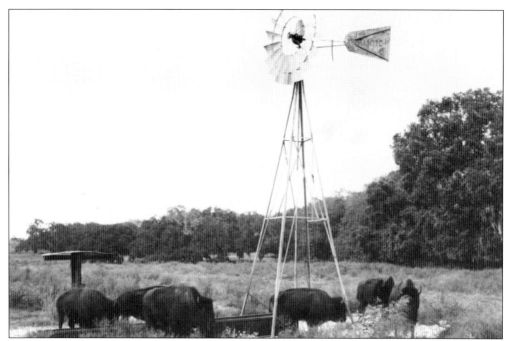

One of Gainesville's popular early attractions was the area now known as Paynes Prairie. The area is ancient and was formed when land settled after the limestone underneath it dissolved. The site was named after a Seminole chief and was marveled at by William Bartram in 1774. Today Paynes Prairie is a blend of wet and dry vegetation with a few spots of open water. This photograph was taken in the 1970s when bison were introduced as an experiment. (Courtesy Florida State Archives.)

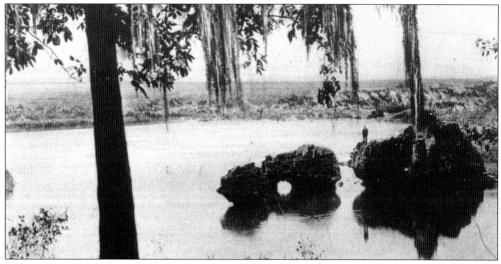

The prairie has not always been so dry, however. At numerous times in its history, the drain to the Florida Aquifer below has become clogged and water has flooded the prairie. This happened in 1867 and killed much of the livestock grazing there. Those waters eventually receded but returned four years later. This is a postcard of a rock formation near the drain. (Courtesy P. K. Yonge Library of Florida History, Department of Special and Area Studies Collections, George A. Smathers Libraries, University of Florida.)

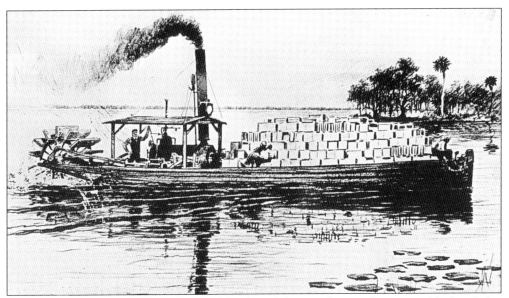

In 1871, the water rose to unprecedented levels and the area became known as Alachua Lake. Oliver Park was built on its shores and quickly became a popular picnic area for tourists on the Florida Southern Railroad and for locals on Sunday outings. Oliver Park even included a zoo. The vessel in this drawing ferried passengers to and from Gainesville but was mainly used to transport crops grown around the lake. (Courtesy Florida State Archives.)

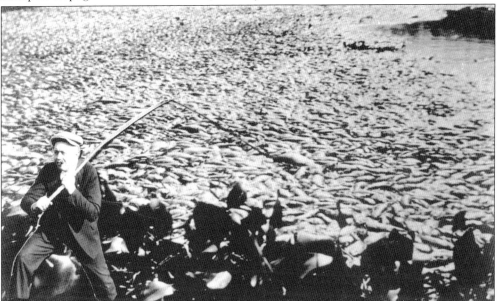

By 1891, the waters began to recede. A year later, they very quickly fell 8 feet, leaving thousands of fish to bake in the sun. The steamboat was also stranded, and Oliver Park lost its luster. This photograph was taken during the aftermath of a similar fish kill that happened in a flooded portion of the prairie in the 1920s. The man was later pasted on to the photograph, apparently as a joke to indicate he had caught all of the fish. Today Paynes Prairie is a state preserve. It is mostly dry now but may return to a lake in the future. (Courtesy University Archives, Department of Special and Area Studies Collections, George A. Smathers Libraries, University of Florida.)

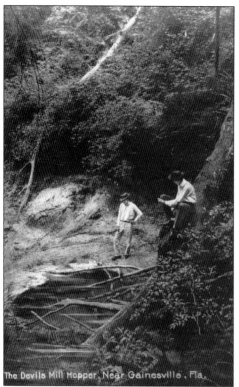

The Devil's Millhopper is another Gainesville-area wonder caused by limestone erosion. It is actually a 500-foot sinkhole that formed about 20,000 years ago. The University of Florida owned the site for a number of years before it became a state park in the 1970s. This is a 1908 postcard depicting the sinkhole. (Courtesy Florida State Archives.)

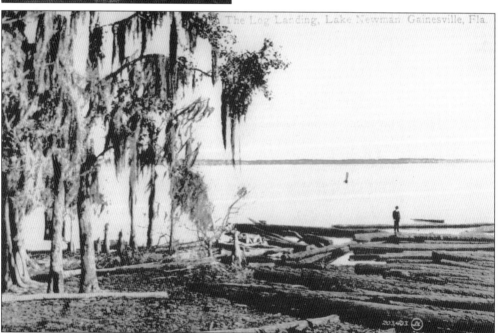

Just east of Gainesville lay another popular place to spend a Sunday afternoon in early Gainesville. Newnan's Lake was frequented by swimmers and boaters. The lake is named after Col. Daniel Newnan, a War of 1812 hero. Many artifacts left by the Native Americans who inhabited the area have been found here. (Courtesy Florida State Archives.)

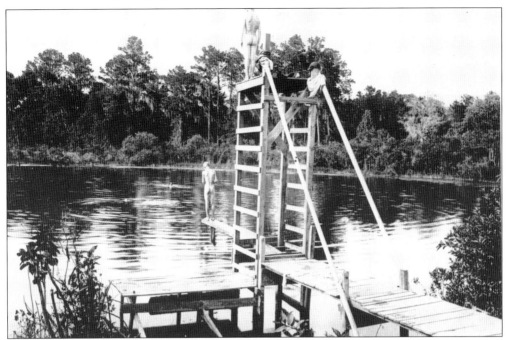

Swimming was a very popular activity in early Gainesville. The many lakes and ponds provided ample opportunities. This photograph of skinny-dippers was taken at an unknown Gainesville-area swimming hole with an impressive diving structure. (Courtesy Florida State Archives.)

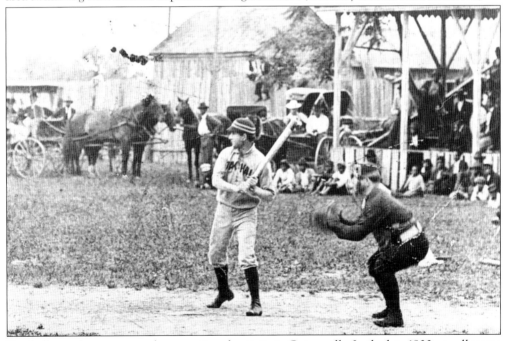

Baseball was also a very popular recreational activity in Gainesville. In the late 1800s, small teams were usually put together by local businesses and competed against teams from similar industries. The Oak Hall baseball team, the local favorite at the time, may have been formed just that way. They are at bat in this photograph from the 1890s. (Courtesy Florida State Archives.)

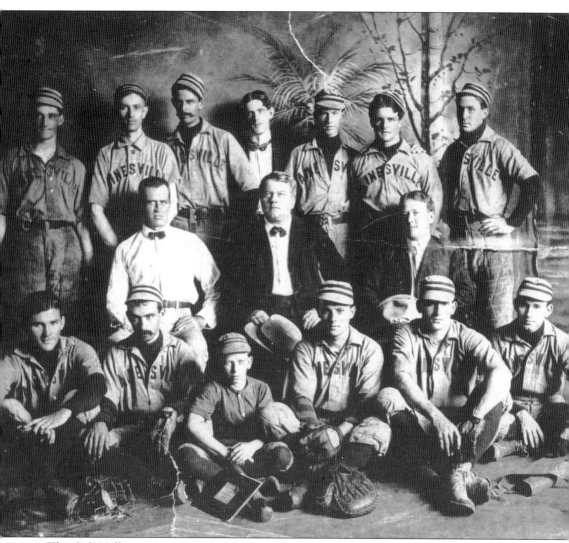

The Oak Hall team was named after the aforementioned home of Tilman Ingram. The team played their games near Oak Hall, which was where the Hippodrome State Theater is now. This portrait was taken of the team in 1903. The players are, from left to right, (first row) Tom McCarroll (outfield), unidentified, Harvey Wallace (mascot), Brian Bogy, (third base), ? Liddion (infield), and Lee Graham; (second row) ? McPherer (manager), Homer Ford, and ? McElwaine; (third row) ? Chappal (pitcher), ? McKinstry (outfield), ? Spencer (center field), ? Layton, ? Morrow (pitcher and first base), ? Harris (second base), and ? Hutchinson (catcher). (Courtesy Florida State Archives.)

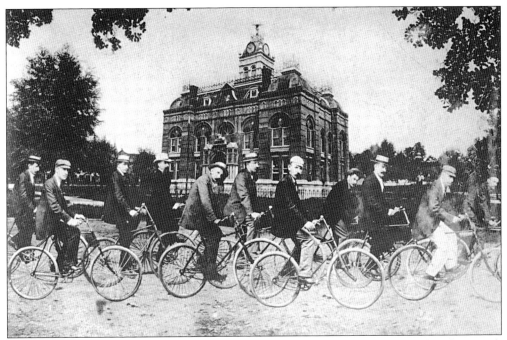

Bicycling must have been a popular leisure activity in Gainesville as is evident from this photograph of the Gainesville Bicycle Club. The caption reads "out for a spin." Minot Bacon Saunders, the partner in O'Donald and Saunders Grocery Store, is the only man identified. He is fifth from left. (Courtesy Florida State Archives.)

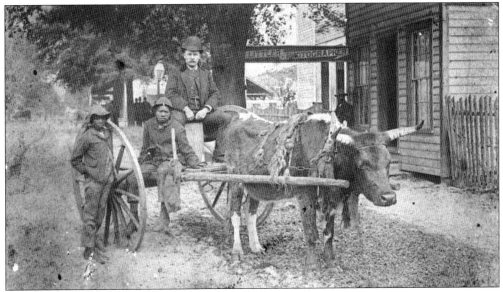

Besides bicycles, there were many means of conveyance used to navigate Gainesville's early roads. The ever-popular oxcart was one of those. This photograph was taken around 1887 in front of Littler's photography shop. Littler, perhaps, took many of the photographs displayed in this book. The white building behind Littler's shop was the first Gainesville Presbyterian Church. The people in this photograph are unidentified. (Courtesy P. K. Yonge Library of Florida History, Department of Special and Area Studies Collections, George A. Smathers Libraries, University of Florida.)

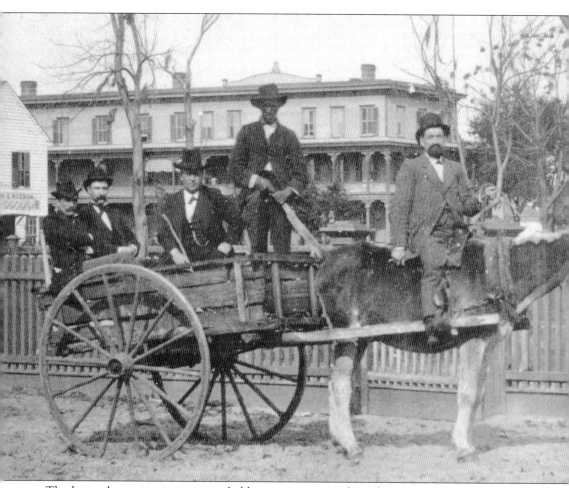

The horse-drawn carriage was probably more common than the oxcart around Gainesville. This carriage poses in front of the Arlington Hotel. The people here are unidentified but may have been associated with the hotel. It is believed that Ulysses S. Grant stayed at the Arlington when he visited the town. Taken in the 1870s, this represents one of the very few photographs to include the hotel. (Courtesy P. K. Yonge Library of Florida History, Department of Special and Area Studies Collections, George A. Smathers Libraries, University of Florida.)

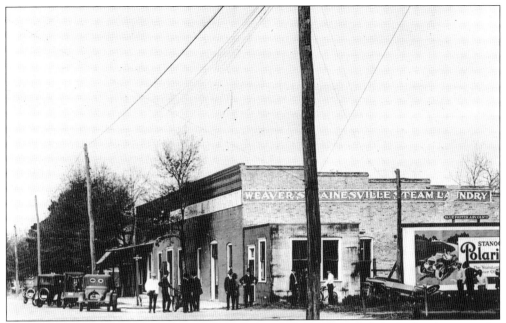

When the automobile finally came to town, it may have taken a while for locals to get the hang of driving. Close inspection of this photograph shows a wrecked car near the sign on the right. This must have been among the first wrecks in Gainesville, as it clearly drew a crowd. The accident happened at the corner of West University Avenue and Northwest Sixth Street. (Courtesy Florida State Archives.)

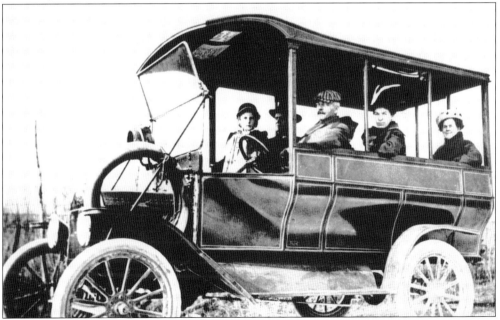

Gainesville residents would eventually become accustomed to driving. This early-1910s photograph was taken as the Rolfs family prepared for a Sunday outing in their larger automobile. Dr. Peter Henry Rolfs was the agricultural dean at the University of Florida for a number of years. Rolfs Hall is named in his honor. (Courtesy Florida State Archives.)

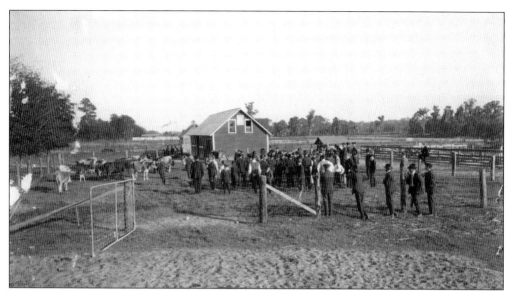

Dr. Rolfs likely kept an eye on the agricultural-based clubs that included many of Gainesville's youths. This photograph portrays a judging of entries at a 4-H Club event. The 4-H Club grew out of the Cooperative Extension Service of the U.S. Department of Agriculture in the early 1900s. Many clubs sprang up around land-grant colleges in agricultural communities. (Courtesy Florida State Archives.)

These were Gainesville's Corn Club Boys. This group and the 4-H Club were started as ways to educate future farmers and generate interest in the industry. Perhaps the more immediate reason for these clubs' inception was to convince the members' fathers, usually farmers themselves, to adapt new technologies. The boys were given new agricultural-based experiments to try with the hopes they would tell their fathers about their achievements. This strategy was rather successful. (Courtesy Florida State Archives.)

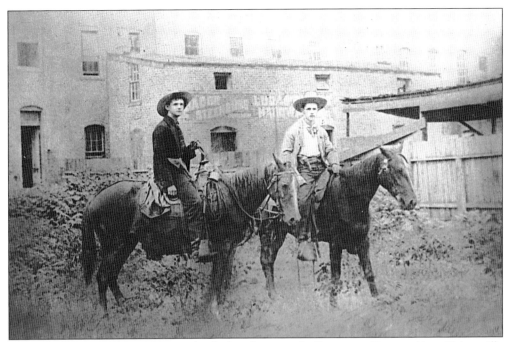

These two cowboys had just driven a herd of cattle across the Suwannee River and into Gainesville for grazing when this photograph was taken in 1890. The gentleman on the left is Archie Jackson, a Confederate veteran. The man on the right is Thomas McDonald. This image was taken behind Steenberg's hardware store on the west side of Courthouse Square. (Courtesy Florida State Archives.)

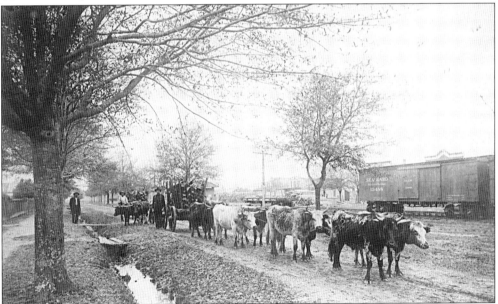

The cattle used for milk and beef production were generally stored in the pens near the southwest side of downtown. The cattle in this photograph were used to pull logs along South Main Street. These logs were probably shipped by Seaboard Airline Railroad, seen in the background. (Courtesy Florida State Archives.)

Some of the travels through the streets of Gainesville served a more festive purpose. This photograph was taken during a parade in the 1890s. One of the carriages supports a sign that says "Our Mayor God Bless Him." (Courtesy University Archives, Department of Special and Area Studies Collections, George A. Smathers Libraries, University of Florida.)

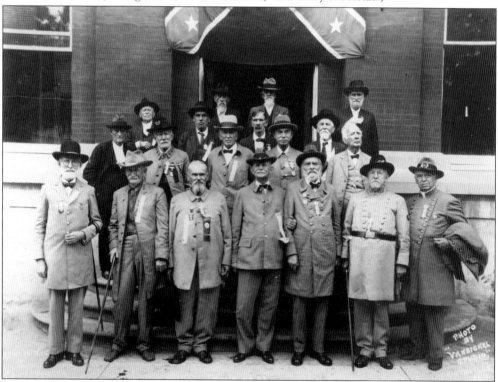

Confederate veterans also filled the streets of Gainesville to remember those they lost and to reunite with friends made during the war. This photograph was taken on the steps of the courthouse at such a reunion held on November 4, 1925. The men are unidentified. (Courtesy Florida State Archives.)

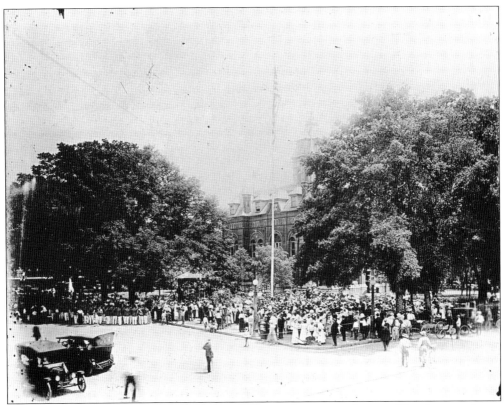

The reason behind this large gathering at Courthouse Square is unknown. The photograph was probably taken sometime around World War I and might have been one of the Fourth of July observances in 1917 or 1918. Many people in the South did not recognize the holiday during this time period because it marked the anniversary of the Battle of Vicksburg, a bitter Confederate defeat. The years 1917 and 1918 did see a rare observance of Independence Day in Gainesville. (Courtesy Florida State Archives.)

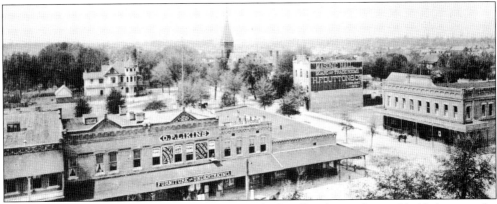

This is a view from atop the courthouse in 1894. It looks off to the northwest. Visible here are the O. P. Likin's furniture and undertaking outfit (foreground), Masonic Hall (to the right), and the steeple of the First Presbyterian Church at 234 West University Avenue (background). (Courtesy Florida State Archives.)

On extremely rare occasions, it does snow in Gainesville, as was the case in this photograph of a snow-dusted home in 1894. This was the second of the three freezes that led to the demise of the "orange fever" Gainesville experienced. Five years later, on February 9, 1899, temperatures fell to as low as 9 degrees Fahrenheit and ended the local orange industry for good. (Courtesy P. K. Yonge Library of Florida History, Department of Special and Area Studies Collections, George A. Smathers Libraries, University of Florida.)

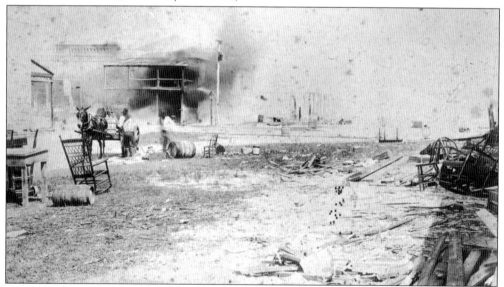

Fire proved more destructive than ice. The fire that destroyed the Arlington Hotel in 1884 was one of four started by an arsonist in a single day. The Varnum Hotel, a private home, and a livery were the other victims. This photograph illustrates the effects of a 19th-century Gainesville fire. The debris in the street was all that was salvaged from the burning building. (Courtesy P. K. Yonge Library of Florida History, Department of Special and Area Studies Collections, George A. Smathers Libraries, University of Florida.)

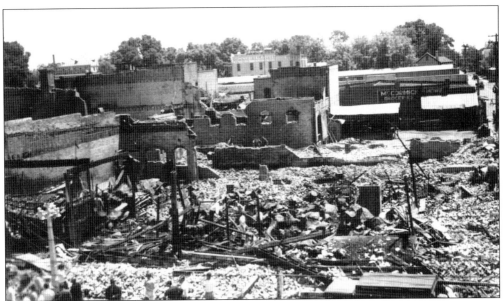

As a result of the 1884 fires, most buildings constructed on Courthouse Square were made of brick thereafter. However, that did not prevent mass fire. This one started near the Cox Furniture Store on May 1, 1938, and caused extensive damage to several buildings. (Courtesy P. K. Yonge Library of Florida History, Department of Special and Area Studies Collections, George A. Smathers Libraries, University of Florida.)

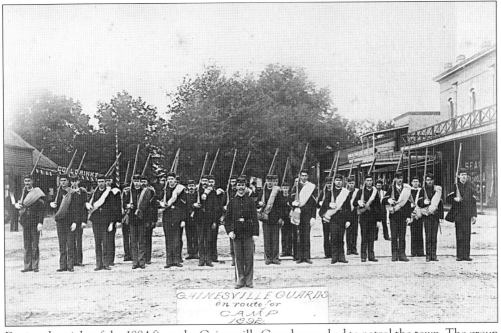

During the night of the 1884 fires, the Gainesville Guard was asked to patrol the town. The group acted as something of a local reserve unit and consisted of many of Gainesville's most notable citizens. They posed for this photograph as they prepared to leave for a camp in 1892. (Courtesy P. K. Yonge Library of Florida History, Department of Special and Area Studies Collections, George A. Smathers Libraries, University of Florida.)

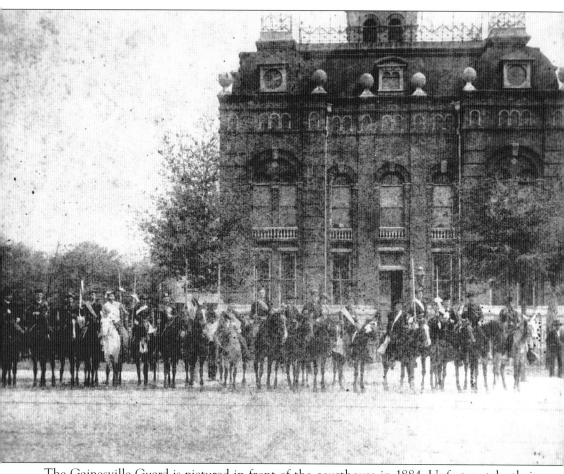

The Gainesville Guard is pictured in front of the courthouse in 1884. Unfortunately, their greatest legacy might have been causing the town more harm than good. Yellow fever struck the state in 1888. An outbreak occurred in Fernandina, but town officials there refused to admit the epidemic, frustrating the citizens. To make matters worse, a strike of longshoreman grew out of control. Fernandina was in turmoil and the Gainesville Guard was sent to maintain order. Once there, they were asked to guard the home of the leader of the longshoremen. His wife was sick with what town officials called typhoid fever. Sadly, the truth was much more serious. Gainesville residents were leery of letting the potentially infected guardsmen return home but were assured the men were okay. By the time they de-boarded the train back in Gainesville, six men had fallen ill. For months, the town was quarantined, and many people left but not before many Gainesville residents lost their lives to Yellow Jack. (Courtesy Florida State Archives.)

A memorial to the Gainesville Guard members who lost their lives to yellow fever was erected on the northeast corner of Courthouse Square. It is seen here in an early postcard. The monument was moved to Evergreen Cemetery in 1922. Dorsey's Grocery Store is seen in the background on the right with the other businesses on the square's north side. These businesses were a sign that Gainesville had overcome much adversity in the last half of the 19th century and was ready for a more modern era. (Courtesy Florida State Archives.)

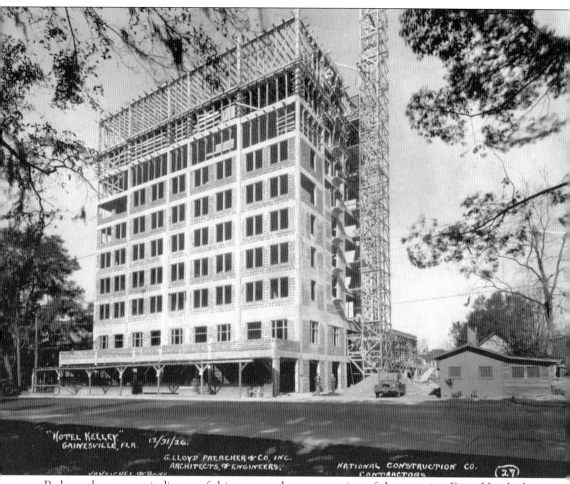

Perhaps the greatest indicator of this era was the construction of the towering Dixie Hotel, also known as the Hotel Kelley. Gainesville was the scene of unprecedented land speculation in the 1920s. During that time, the land at 408 West University Avenue changed hands several times with impressive inflation until it fell into the possession of McKee Kelley. He began construction of the hotel in 1926 at the cost of $600,000. Half of this was to be contributed by local investors. Construction reached the 10th of 11 planned floors when the economy began to fail at the end of the decade. Kelley and his investors had run out of money, and the building sat unfinished. (Courtesy University Archives, Department of Special and Area Studies Collections, George A. Smathers Libraries, University of Florida.)

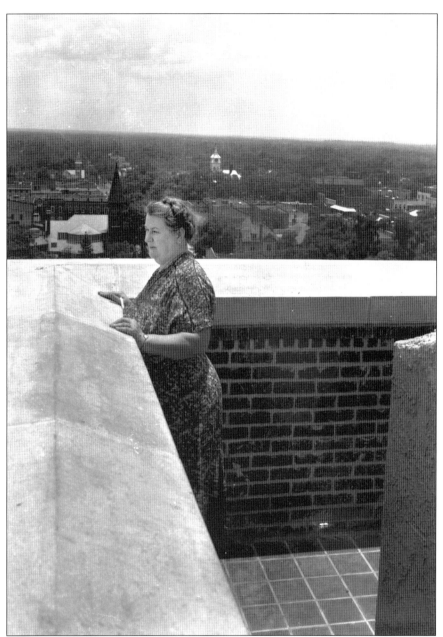

Throughout the first half of the 1930s, the building served as a reminder of the failed economy. By 1935, the Works Progress Administration had become interested in the building. Local resident Georgia Seagle became involved and put up $20,000 for the property. The city and county provided the rest. The building was deeded to the state and completed with the help of the University of Florida's College of Architecture. It was renamed the Seagle Building in honor of Seagle's late brother, John. For many years, it was the home to the Florida State Museum and used by the university. The building was also ranked among the tallest in the Southeast. In the 1980s, it was converted to residential, office, and retail space. Georgia Seagle is seen looking out from the top of the building. (Courtesy University Archives, Department of Special and Area Studies Collections, George A. Smathers Libraries, University of Florida.)

The Duck Pond neighborhood was a result of the boom of the 1920s that led to the Dixie Hotel debacle. The pond was originally named Vidal's Lake and is a retained portion of Sweetwater Branch. The neighborhood that surrounds it was once partially owned by Major Thomas as part of his Sunkist Villa and is among the more desirable neighborhoods in Gainesville. The pond is seen here along with some workers from Baird Hardware. (Courtesy Florida State Archives.)

The University Heights neighborhood began in the early 1900s and expanded throughout the first half of the century. Adjacent to the University of Florida, it served as the residence for many of those associated with the school. The neighborhood is now popular with students, although many in town would like to see the area receive more care. This photograph depicts a home in the neighborhood in 1949. (Courtesy Florida State Archives.)

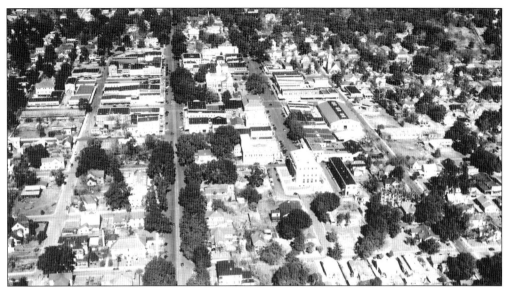

More of Gainesville's neighborhoods as they stood in the mid-1930s are seen in this aerial photograph looking north toward downtown Gainesville. The back of the post office (Hippodrome State Theater) is seen at the foot of Southeast First Street in the center of the frame. Just northwest of that, the second Alachua County Courthouse is visible. (Courtesy P. K. Yonge Library of Florida History, Department of Special and Area Studies Collections, George A. Smathers Libraries, University of Florida.)

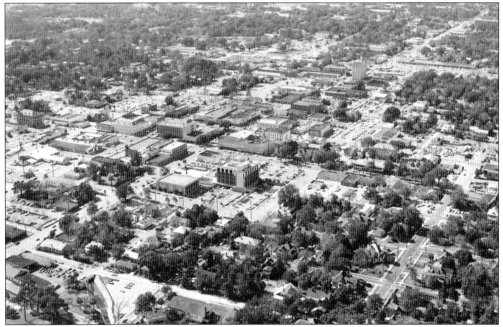

This aerial was taken about 30 years later in 1968. It looks southwest toward the city. The same post office is seen on the very left side of the frame, but the second Alachua County Courthouse has been replaced. Many of the other buildings here had changed their purpose in the years between these photographs. (Courtesy P. K. Yonge Library of Florida History, Department of Special and Area Studies Collections, George A. Smathers Libraries, University of Florida.)

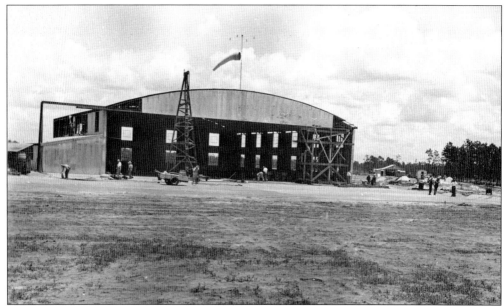

The aircraft that captured the previous photograph likely took off from Gainesville Municipal Airport. The construction that is seen here began on the airport in 1941 as another local Works Progress Administration project. The facility was first used by the Army Air Corps and Army Air Force. The city took over operations in 1948, and in 1977, it was renamed the Gainesville Regional Airport. (Courtesy Florida State Archives.)

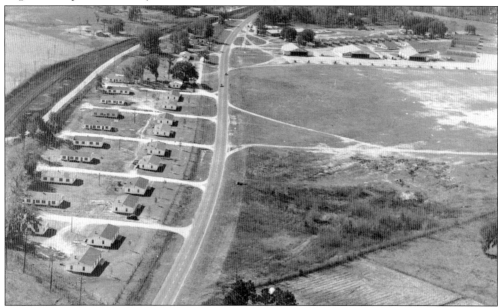

Stengel Field, near the present location of Butler Plaza on Archer Road, was also an area used as an airport. Carl Stengel ran a flight school there that was very popular with University of Florida students. He first started giving his lessons at the site of Gainesville Regional Airport in the 1930s before the military took it over. Stengel served as the first manager of Gainesville's airport. (Courtesy P. K. Yonge Library of Florida History, Department of Special and Area Studies Collections, George A. Smathers Libraries, University of Florida.)

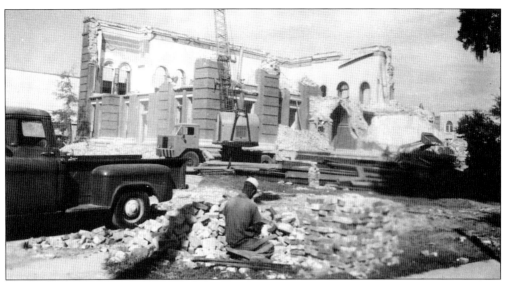

As Gainesville's population continued to expand, the need for more modern and larger municipal buildings persisted. The county's grandiose 1885 courthouse was a victim of that need and was torn down in 1961. This photograph depicts a scene in that process. The building that replaced it was converted to a county administration building in 1976, and a fourth courthouse was built that is still in use. (Courtesy University Archives, Department of Special and Area Studies Collections, George A. Smathers Libraries, University of Florida.)

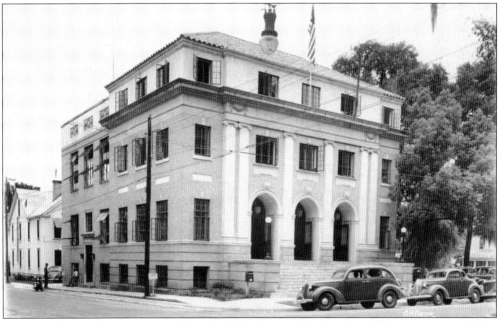

A city administration building was also needed. This 1927 brick-and-marble structure served that purpose. It was built at 117 Northeast First Street. The police department and jail were located in the basement. This building is also seen behind Lewis Fennell on page 48. It was torn down in 1968 and replaced by the present city hall seen in the center of the more recent aerial photograph on page 83. (Courtesy University Archives, Department of Special and Area Studies Collections, George A. Smathers Libraries, University of Florida.)

Businesses also adapted to more modern needs. The Star Garage building began as a livery in 1903 but was changed in 1917 to a garage that sold Cadillacs and Studebakers. The building eventually served as a bus station and held a business that painted airplanes. It was restored by the city in 1977 and is now law offices. (Courtesy P. K. Yonge Library of Florida History, Department of Special and Area Studies Collections, George A. Smathers Libraries, University of Florida.)

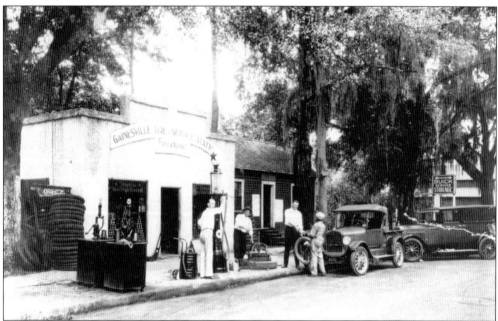

This service station likely tuned up some of the cars sold at the Star Garage. Pictured from left to right are Matthew Mathias Miller, Jack Neal Adams, Virgil Goolsby, and a man simply known as "Bostie." Signs in the photograph point the way to Lake City and an area for the storage and maintenance of Buick cars. (Courtesy P. K. Yonge Library of Florida History, Department of Special and Area Studies Collections, George A. Smathers Libraries, University of Florida.)

The First National Bank was the only bank in Gainesville to survive the Great Depression. It began in 1888 at 15 North Main Street, as seen here. In 1954, the bank moved to a new building at 104 North Main Street. That property previously held the Atlantic Coast Line ticket office seen on page 57. (Courtesy Florida State Archives.)

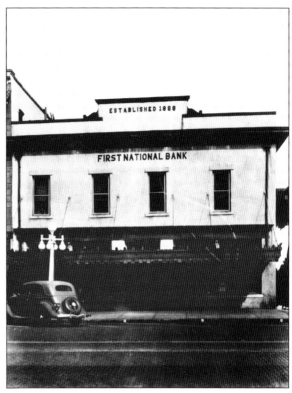

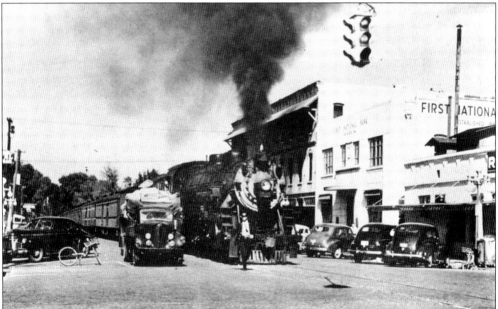

Before the Atlantic Coast Line ticket office closed, the train ran right down Main Street. A city ordinance set a speed limit of four miles per hour for the train and a railroad employee called the flagger ran alongside the train waving a red flag. The train and flagger are seen here headed down Main Street. (Courtesy P. K. Yonge Library of Florida History, Department of Special and Area Studies Collections, George A. Smathers Libraries, University of Florida.)

During the 1930s, a new industry developed in Gainesville. Tung oil is a product originating from China that was used as a chief component in paint. It was regarded as being of better quality than the more commonly used linseed oil. Gainesville had a similar climate to the area in China in which tung nuts were grown, so it was decided to try to grow the crop in Alachua County. This photograph shows tung nuts being gathered close to Gainesville. (Courtesy Florida State Archives.)

The idea proved successful, and by 1940, ninety percent of the domestic crop was grown around Gainesville. Tung oil was shipped from Gainesville all over the world. The endeavor was so successful a tung oil parade was held, seen here. However, several freezes soon threatened the industry, and cheaper synthetic products were developed during the Second World War that essentially ended the demand for tung nuts. (Courtesy Florida State Archives.)

Four

EDUCATION

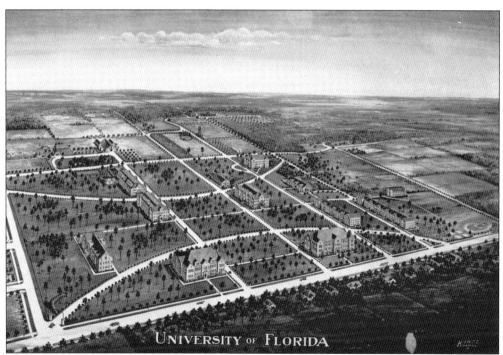

Today Gainesville is best known as an educational epicenter. The University of Florida is the leading factor in this reputation. However, the school did not form overnight, and the town has a rich educational history beyond the university. This is an early sketch of the university's grounds. (Courtesy University Archives, Department of Special and Area Studies Collections, George A. Smathers Libraries, University of Florida.)

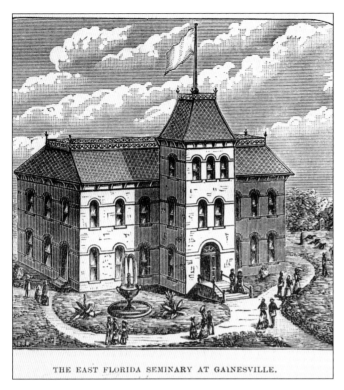

THE EAST FLORIDA SEMINARY AT GAINESVILLE.

The city's education industry actually began in Ocala in 1853. That year, the state legislature agreed to support two public schools on either side of the Suwannee River. In 1853, an existing school in Ocala known as the East Florida Seminary was granted a portion of these funds as the designated school on the east side of the river. Three years later, James Henry Roper established Gainesville Academy. With the Ocala school facing financial turmoil, Roper convinced the state to merge the two schools, and the East Florida Seminary moved to Gainesville in 1866. The school later constructed Epworth Hall, seen in this 1883 etching. (Courtesy Florida State Archives.)

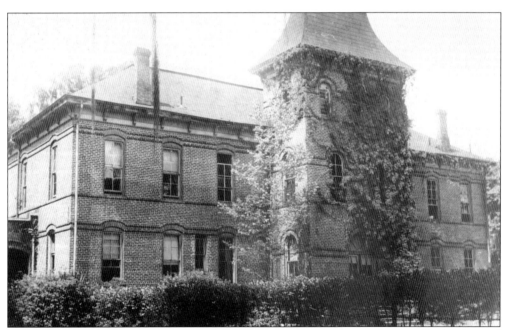

This building replaced the original East Florida Seminary structure in Gainesville that burned in the early 1880s. It was the school's primary building and held classrooms, a library, and offices. It is now owned by First Methodist Church, who named it Epworth Hall. (Courtesy Florida State Archives.)

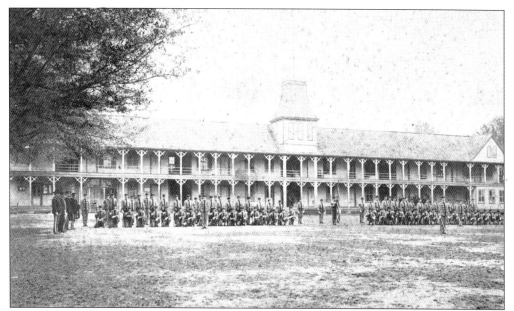

This building served as the dormitory for students at the East Florida Seminary. It was 197 feet long by 90 feet wide and featured beds, bathrooms, a kitchen, and an infirmary. The building burned in the early 1910s, and the property is now home to Roper Park. (Courtesy Florida State Archives.)

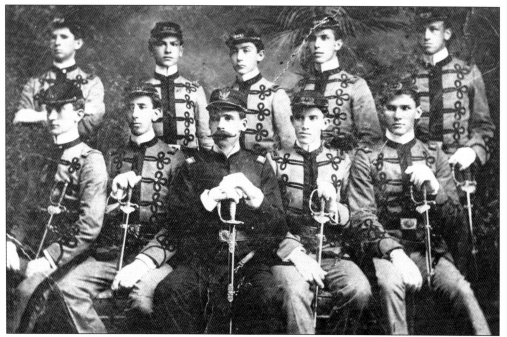

The East Florida Seminary had a strong military tradition. It required male students to dress in uniform and held a full arsenal of cadet rifles in addition to some artillery. A group of cadets poses here. Pictured from left to right are (first row) Ted Carroll, James Blanding, and three unidentified; (second row) James Fennell, two unidentified, Harry Knight, and Tom Campbell. (Courtesy Florida State Archives.)

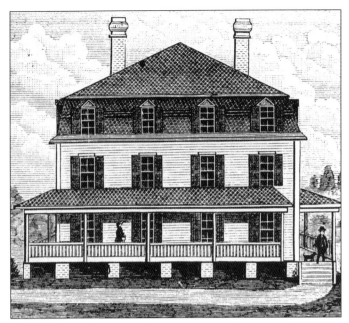

After the war, many private institutions opened in Gainesville either by clergy or other individuals looking to profit while providing area youth with a needed education. One such school was Chateau-Briant. This large, three-story building was located on Northwest Ninth Avenue. The school boarded female students upstairs but also served boys during the day. (Courtesy P. K. Yonge Library of Florida History, Department of Special and Area Studies Collections, George A. Smathers Libraries, University of Florida.)

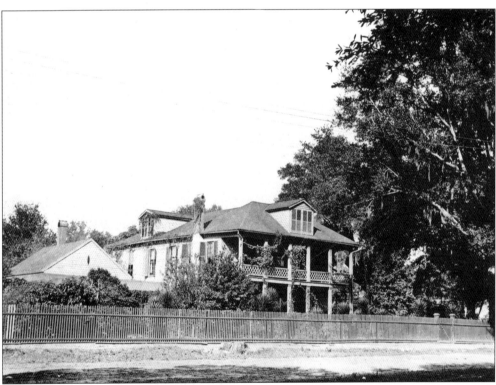

Perhaps the most popular of the smaller schools that opened in Gainesville was Miss Maggie Tebeau's Boarding and Day School. It opened in 1873 near Courthouse Square but soon moved to the building seen here, once located at the southwest corner of South Main Street and Southwest Second Avenue. The school was highly regarded around town and remained in operation until 1936. (Courtesy Florida State Archives.)

Miss Maggie, as she was known, was so impressive as an educator that the Episcopal Church declared the school the Diocesan School for Girls of the Florida Diocese of the Protestant Episcopal Church in 1909. Miss Maggie died in 1924 and was laid to rest in Evergreen Cemetery. Her niece, Alice Thomas, took over operations of the school. (Courtesy Florida State Archives.)

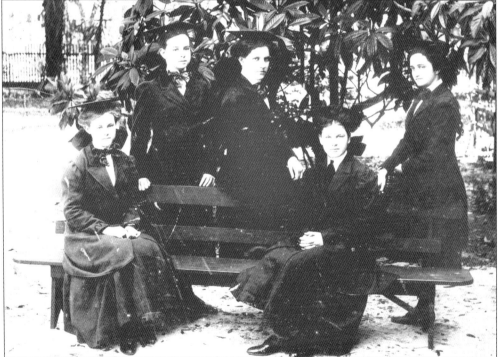

The school typically boarded 10 to 15 young ladies at a time but also educated young men during the day. A group of graduates from the school are seen here. Kate Clyatt Trenton is pictured on the left. Annie Pound is on the right. The other girls are not identified. (Courtesy Florida State Archives.)

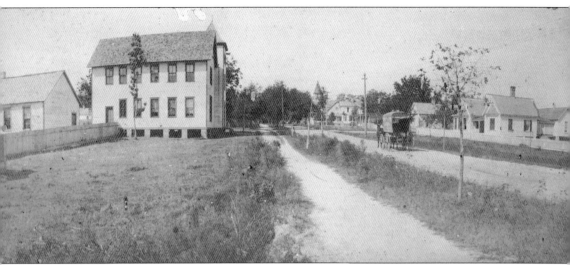

Prior to 1885, students of almost any means attended the several private schools. The town's very poorest students either received no education at all or were educated publicly under the most deplorable conditions. William Sheets, superintendent of public schools, began to campaign vigorously for funds to construct a sound public schoolhouse in the early 1880s. While many were against Sheets, his efforts met success in 1885 when the building on the left of this photograph was constructed at East University Avenue and Southeast Fourth Street. The 1897 version of the First Baptist Church, complete with its tower, can be seen in the background. The wagon traveling along East University Avenue advertised the Diamond Ice Company. (Courtesy P. K. Yonge Library of Florida History, Department of Special and Area Studies Collections, George A. Smathers Libraries, University of Florida.)

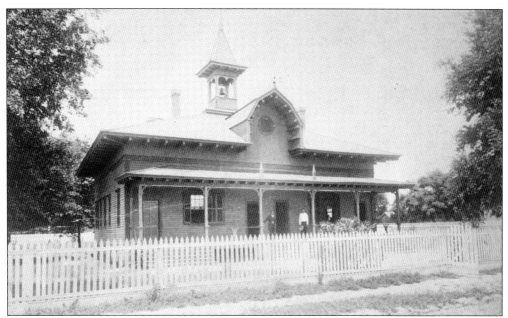

After the Civil War, the need to educate freed slaves and other blacks arose. Union Academy served that purpose. The school was located at the southwest corner of Seventh Avenue and Northwest First Street. The school opened in 1866 with funds from the Freedmen's Bureau. The George Peabody Fund also contributed. For many years, the school offered a better public education experience than its white counterpart, and by 1898, enrollment had almost tripled to 500 students. An addition was built onto the original structure as seen in these two photographs. (Courtesy Florida State Archives.)

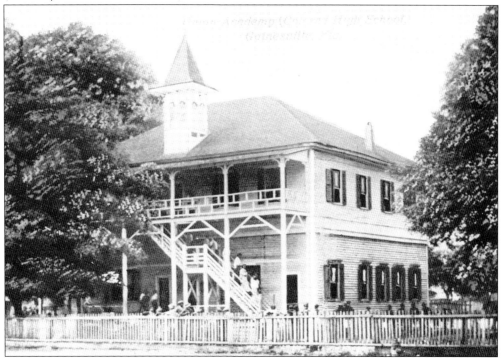

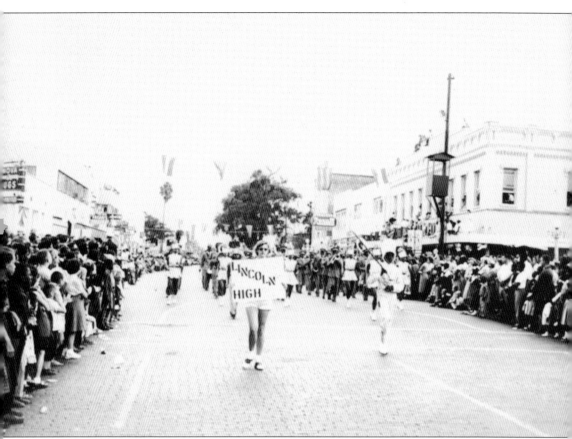

African American access to education in Gainesville was not always so easy, however. Many in town opposed the construction of Union Academy. The school's white teachers, relocated from the North, were met with scorn around town. Union Academy's enrollment continued to grow after the addition was built, but little was done to keep the school in repair. Classes began to meet in cottages surrounding the school until 1923, when the Lincoln School was built on Northwest Tenth Street. It is now known as the A. Quinn Jones Center, named after the school's first principal. The school's band performs here in the 1954 University of Florida Homecoming Parade. (Courtesy University Archives, Department of Special and Area Studies Collections, George A. Smathers Libraries, University of Florida.)

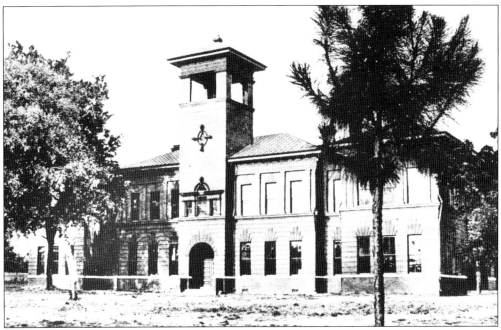

After 1900, most of the white children in Gainesville attended the Gainesville Graded and High School at 620 East University Avenue. Seen here, the building was expanded several times. In 1923, it was renamed Eastside Elementary. After a 1939 expansion, the building was given the name it still bears, that of Gen. Edmund Kirby-Smith. (Courtesy Florida State Archives.)

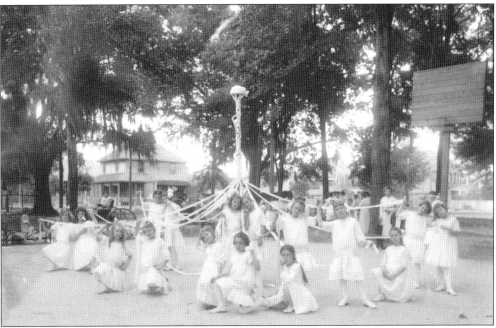

It is worth noting that three of the school's first four principals went on to become state superintendent of public education. In the 1980s, the school was converted into the offices of the Alachua County School Board. A group of students is seen here participating in May Day festivities. (Courtesy Florida State Archives.)

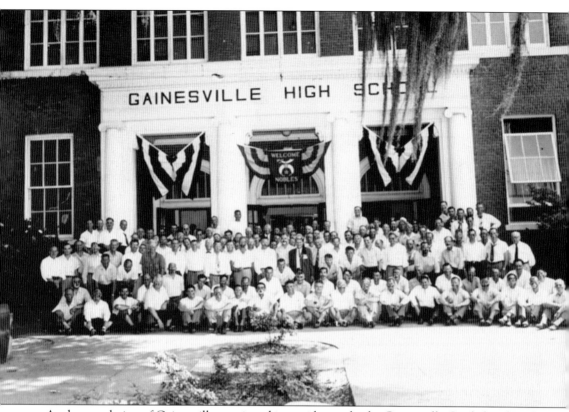

As the population of Gainesville continued its rapid growth, the Gainesville Graded and High School failed to meet the town's demands. Thus, more schools were needed and Gainesville High School was built at the same time as the Lincoln School for African American children. This school stood at 723 West University Avenue. In 1957, it became a middle school after the present Gainesville High School on Northwest Thirteenth Street was built. (Courtesy University Archives, Department of Special and Area Studies Collections, George A. Smathers Libraries, University of Florida.)

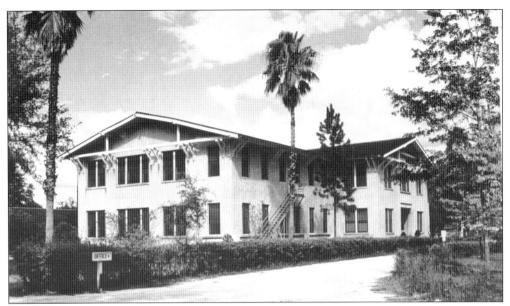

A school was also needed to educate disabled children. In 1921, this school opened at 1621 Southeast Waldo Road as the Florida Farm Colony for the Feeble-Minded and Epileptic. It has since been known as the Sunland Training Center and Tacachale and remains in operation. (Courtesy Florida State Archives.)

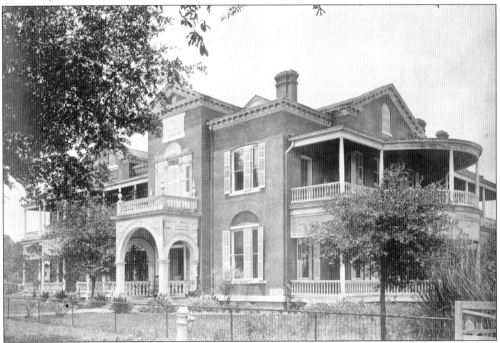

A fraternal organization known as the Odd Fellows established the Odd Fellows Home and Sanitarium as a tuberculosis sanitarium in 1897. Before it was torn down in 1974, it also housed a school for girls and an orphanage. This building stood at 740 Southeast Second Avenue. (Courtesy P. K. Yonge Library of Florida History, Department of Special and Area Studies Collections, George A. Smathers Libraries, University of Florida.)

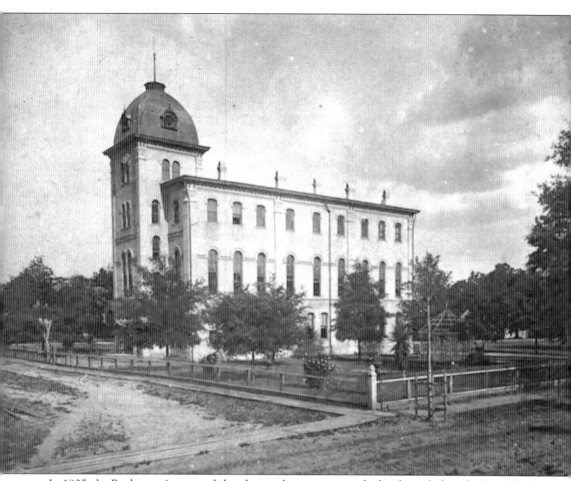

In 1905, the Buckman Act consolidated several state-supported schools, including the East Florida Seminary and the Florida Agricultural College in Lake City. This c. 1897 photograph illustrates the latter school's Lecture Hall. There were four schools created from the Buckman Act: the Florida Normal and Industrial College for Negroes; the Blind, Deaf, and Dumb Institute; the Florida Female College (which would become Florida State University); and, serving white males, the University of the State of Florida, which would be shortened to the University of Florida in 1909. The question remained as to where to locate these schools. (Courtesy Florida State Archives.)

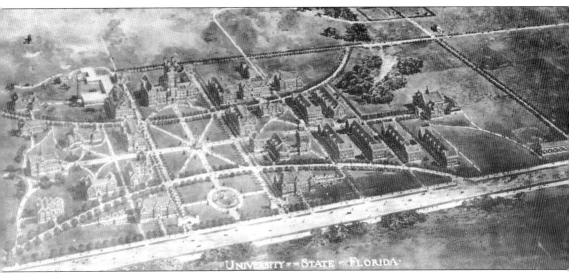

The first three schools found their homes in due time. Gainesville and Lake City quickly emerged as the front-runners for what would become the University of Florida. In the summer of 1905, an inspection party came to Gainesville and was treated royally at the East Florida Seminary. They received similar treatment in Lake City, and debate spread throughout the state as to where the school should be located. Ultimately, under the leadership of Mayor William Thomas, Gainesville's offer of 500 acres east of the city, $40,000, and a free water supply sealed the deal. The celebration the people of Gainesville had when they received the news on July 6 was unmatched. An impromptu community-wide parade was held complete with bonfires and the constant ringing of church bells. The firm of Edwards and Walter was selected to design the campus. An early conceptual sketch is seen here. (Courtesy P. K. Yonge Library of Florida History, Department of Special and Area Studies Collections, George A. Smathers Libraries, University of Florida.)

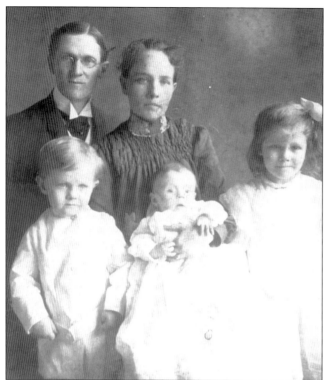

Andrew Sledd was selected to serve as the university's first president. Previously he had served as president of the University of Florida at Lake City. He was among those who lobbied for the consolidation of state schools through the Buckman Act and was instrumental in the university's move to Gainesville. He is pictured with his wife, Annie Florence (Candler), and their children. (Courtesy University Archives, Department of Special and Area Studies Collections, George A. Smathers Libraries, University of Florida.)

Sledd Hall was, of course, named after Andrew. It serves as a dormitory and opened in 1929. The building was designed by Rudolph Weaver, who designed many of the older buildings on campus. The building features the seals of some of the worlds greatest universities including Harvard and Yale, both of which Sledd attended. The south tower also features the name Mucozo, a Timucuan Indian chief who befriended the Spanish when they first arrived in Florida. (Courtesy University Archives, Department of Special and Area Studies Collections, George A. Smathers Libraries, University of Florida.)

Albert Murphree served as the first president of Florida Female College and was the leading candidate for the University of Florida job when the school moved to Gainesville. However, Murphree did not have the same support of the governor that Sledd did. After the gubernatorial election of 1908, Sledd was forced out of office and Murphree took over in 1909. He remained president until 1927. (Courtesy University Archives, Department of Special and Area Studies Collections, George A. Smathers Libraries, University of Florida.)

Murphree Hall is also a dormitory. It opened in 1939 and was among the last of Weaver's designs. It housed families of veterans during World War II. With its close proximity to the stadium, Murphree Hall also housed the football team for a short time. (Courtesy University Archives, Department of Special and Area Studies Collections, George A. Smathers Libraries, University of Florida.)

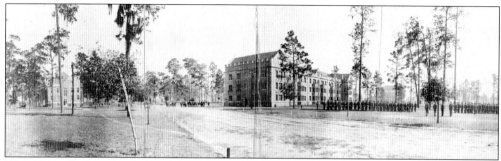

Thomas Hall was one of the first two buildings completed on campus and originally served several different purposes. The building was named for the aforementioned William Rueben Thomas, who served as mayor when Gainesville was selected as the new site for the school. He was instrumental in that role. The building was later connected to Sledd Hall, and along with Fletcher Hall, the trio spell "UF" when seen from above. This photograph was taken in 1915. (Courtesy University Archives, Department of Special and Area Studies Collections, George A. Smathers Libraries, University of Florida.)

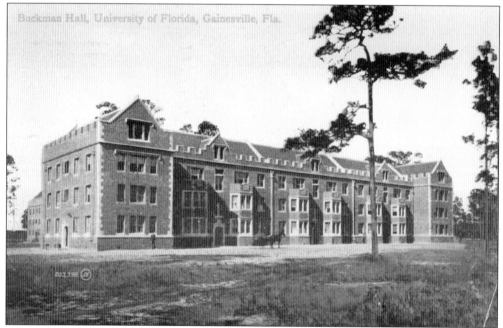

Buckman Hall was the other original building on campus and also had a multipurpose use. It is named for Henry Buckman, the senator from Duval County for which the bill that consolidated the schools was named. A horse and buggy stand in front of the building in this postcard. Initially the campus was so rural a gate had to be installed to keep livestock from grazing on school grounds. (Courtesy Florida State Archives.)

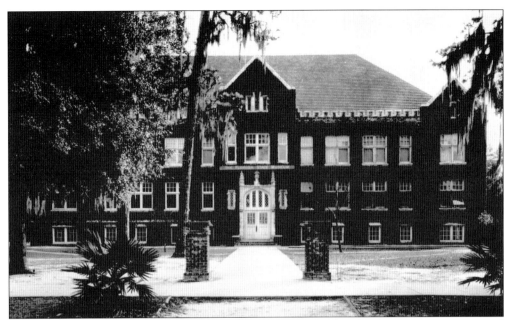

Science Hall opened in 1910 to serve the science department. The Florida State Museum opened on its second floor in 1914. For a while, the building was used as storage and was allowed to deteriorate. It was eventually restored and renamed Flint Hall to honor Edward Rawson Flint, a faculty member at Florida Agricultural College who established the school's infirmary. (Courtesy University Archives, Department of Special and Area Studies Collections, George A. Smathers Libraries, University of Florida.)

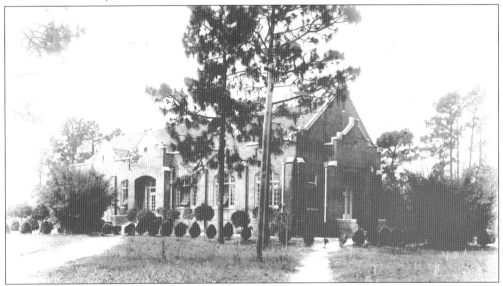

Johnson Hall was the victim of fire in 1987. The building was completed in 1912 and served as a dining hall and commons area. It was located where Farrior Hall sits today. Before the fire, the building had a healthy population of bats that were forced to move to the track and tennis stadiums prior to construction of the bat house on Museum Road. (Courtesy University Archives, Department of Special and Area Studies Collections, George A. Smathers Libraries, University of Florida.)

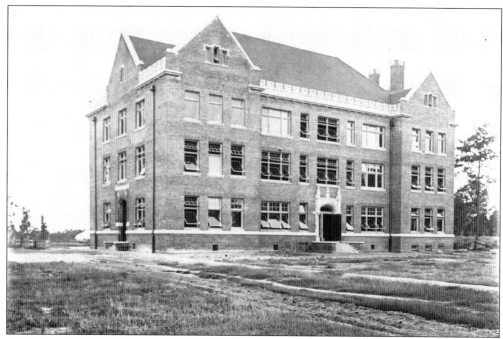

The Florida Agricultural Experiment Station opened in 1910. It was surrounded by fields and gardens used for research. In 1944, it was renamed Newell Hall after Dr. Wilmon Newell, who directed the station. (Courtesy Florida State Archives.)

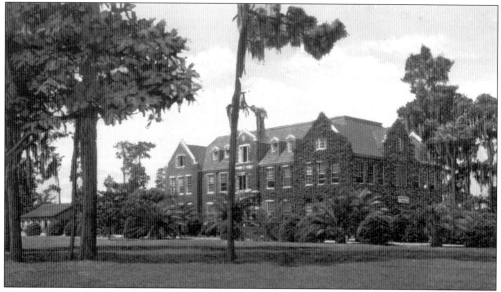

The rural school's agricultural ties would continue with the construction of Floyd Hall in 1912 for the College of Agriculture. Room was provided on the first floor for cattle judging, and the second floor held a chapel. Like Flint Hall, it was dormant for a number of years. Ben Hill Griffin Jr., for whom the football stadium is named, made a sizable donation to keep the building from demolition. The building is named after Maj. Wilbur Floyd, a former College of Agriculture dean. (Courtesy University Archives, Department of Special and Area Studies Collections, George A. Smathers Libraries, University of Florida.)

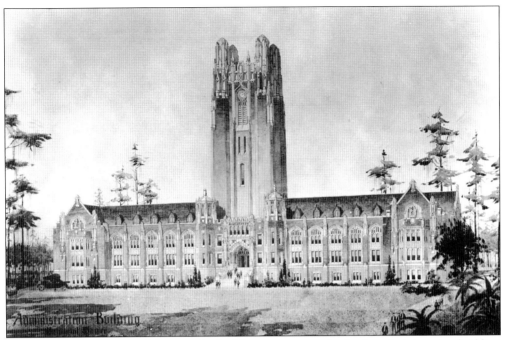

Among the school's original designs, this building was proposed to be the administration building and the centerpiece for the campus. While it certainly would have been impressive, the building was never actually constructed. (Courtesy P. K. Yonge Library of Florida History, Department of Special and Area Studies Collections, George A. Smathers Libraries, University of Florida.)

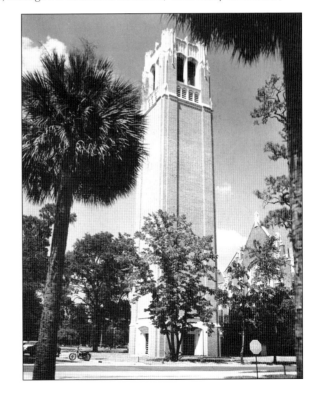

Perhaps the previous building served as inspiration for Century Tower. Ground broke on the tower in 1953, a hundred years after the university marks its beginnings. It is 157 feet tall and counts 194 steps to the top. A 49-bell carillon is found there. The largest bell weighs three and a half tons. (Courtesy Florida State Archives.)

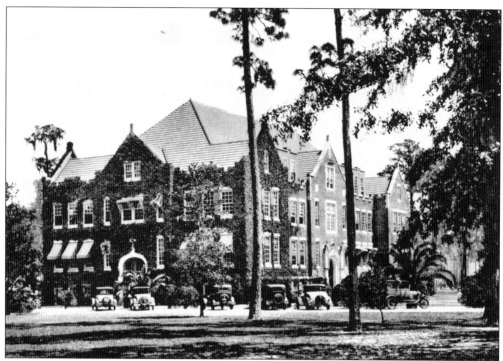

What is now known as Anderson Hall began as a multipurpose building known as Language Hall in 1913. It housed English, math, and history classes as well as the offices of the university president. It was renamed in honor of James Nesbitt Anderson, the first dean of the College of Arts and Sciences and the Graduate School. (Courtesy University Archives, Department of Special and Area Studies Collections, George A. Smathers Libraries, University of Florida.)

In 1914, Bryan Hall was built for the university's law school, which had previously called Thomas Hall home. The building was expanded in 1941 and again in 1950. In 1968, the College of Law moved to another location on campus while Bryan Hall became part of the College of Business Administration. Its namesake is Nathan Bryan, who, as head of the Board of Control, determined much of the layout of the campus. (Courtesy University Archives, Department of Special and Area Studies Collections, George A. Smathers Libraries, University of Florida.)

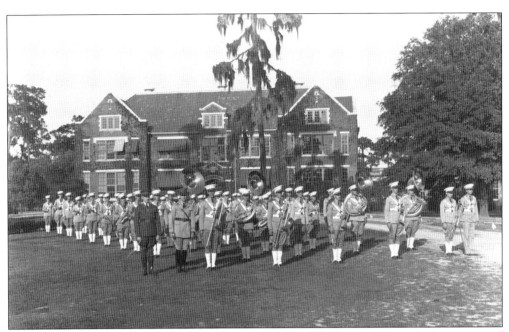

Benton Hall, razed in 1966, was the original home of the College of Engineering when it opened in 1911. It sat on Union Road where Grinter Hall is today and was named after John Benton, the first dean of the college. The university band is seen here marching in front of the building in the 1920s. (Courtesy University Archives, Department of Special and Area Studies Collections, George A. Smathers Libraries, University of Florida.)

The Plaza of the Americas was part of the campus's original plan but did not take that name until 1931. University president John Tigert hosted an international meeting with representatives from several North and South American countries. Twenty-one trees were planted to mark this occasion, and the open area was given its current name. (Courtesy Florida State Archives.)

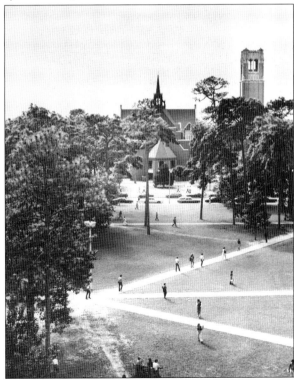

John Tigert served as commissioner of education in the Harding and Coolidge administrations before becoming president of the University of Florida in 1928. Before he retired in 1947, Tigert successfully guided the university through the economic hardships of the Great Depression and the impact World War II had on the student body. The present administration building was named in his honor. He is seen here in a field of sea island cotton used for research. (Courtesy University Archives, Department of Special and Area Studies Collections, George A. Smathers Libraries, University of Florida.)

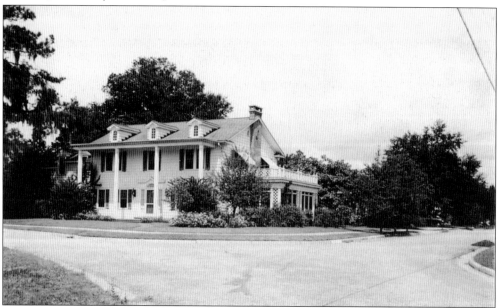

Tigert lived in this house at 224 Northeast Tenth Avenue. The university rented the house for their presidents, as the size allowed them to entertain guests. The 17-room Colonial Revival home featured a staircase that duplicated the one at Mount Vernon in Virginia. (Courtesy University Archives, Department of Special and Area Studies Collections, George A. Smathers Libraries, University of Florida.)

When Tigert retired, J. Hillis Miller took over after serving as commissioner of education for the State of New York. Miller saw the university's enrollment triple after World War II thanks to the GI Bill. The collection of health science buildings is named in his honor, as he was key in establishing the medical school. (Courtesy University Archives, Department of Special and Area Studies Collections, George A. Smathers Libraries, University of Florida.)

Miller lived in the home on the previous page until 1953, when a presidential mansion was built closer to the school at 2151 West University Avenue. The new home provided more room for university presidents to entertain. Unfortunately, Miller did not get to enjoy the home for long. He died unexpectedly shortly after the house was completed. (Courtesy Florida State Archives.)

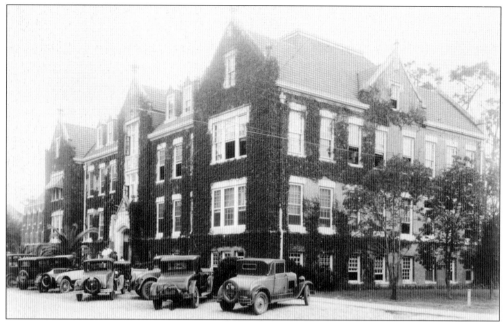

Peabody Hall was completed in 1913 with funds provided by the George Peabody Foundation. The building served the College of Education. For a number of years, it housed a library and the school newspaper, the *Florida Alligator*, in its basement. (Courtesy University Archives, Department of Special and Area Studies Collections, George A. Smathers Libraries, University of Florida.)

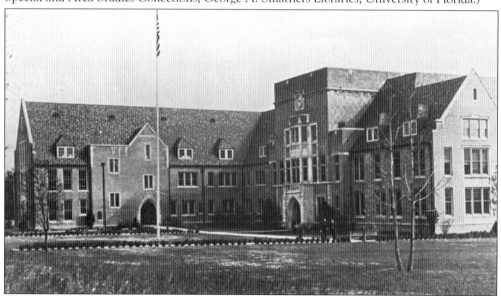

What is now known as Norman Hall was built in 1934 as the P. K. Yonge Laboratory School and named after the longtime head of the state education board. The school initially served 470 students from kindergarten to high school. It was used by the university to train male teachers in the field of education. In 1958, a new laboratory school was built nearby and the headquarters of the College of Education moved here. Additions were made to the building in 1979. (Courtesy University Archives, Department of Special and Area Studies Collections, George A. Smathers Libraries, University of Florida.)

In the beginning, several buildings housed libraries, and the closest thing to a main library moved around several small rooms. In 1925, a main library was finally built on campus. When an additional library building was opened in 1967, the original main library became known as Library East. Philip Keyes Yonge and his son, Julien, both had a keen sense of state history. By the 1940s, they had assembled a large collection of historical items, which they were persuaded to move from their home in Pensacola to Gainesville. Today this library holds their collection and several other special collections. The photograph at right depicts the grand interior reading room; the lower photograph was taken of the building's exterior in the 1940s. (Courtesy University Archives, Department of Special and Area Studies Collections, George A. Smathers Libraries, University of Florida.)

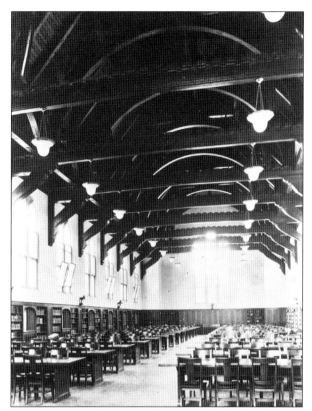

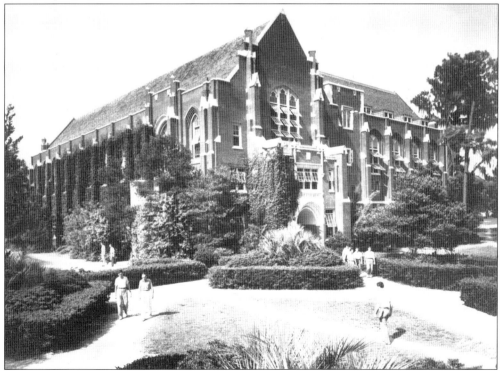

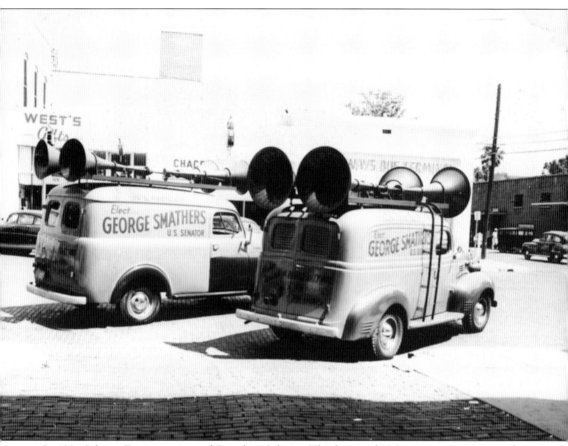

In 1991, Library East was renamed Smathers Library. This honored U.S. senator George Smathers, who donated $20 million to the university that same year. Smathers was an alumnus of the school where he served as a member of Florida Blue Key, captain of the basketball team, and student body president. After serving in the U.S. House of Representatives, he was elected to the Senate in 1950 and unsuccessfully ran for president in 1960. These trucks rode through Gainesville during one of his campaigns. (Courtesy Elmer Harvey Bone Photographic Collection, University Archives, Department of Special and Area Studies Collections, George A. Smathers Libraries, University of Florida.)

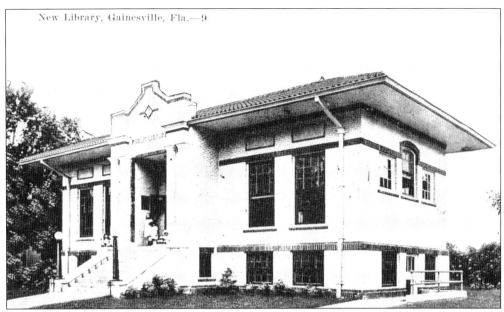

The city of Gainesville had its own public libraries. This was the first building constructed for that purpose. It opened in 1918 at 419 East University Avenue, where the present Alachua County Public Library sits. The effort to build a library was started by a group of local women known as the Twentieth Century Club. It was completed with voter-approved taxes and funds from the Carnegie Library Association. (Courtesy Florida State Archives.)

More and more library space was needed as Gainesville continued to grow. The 1918 library was replaced by another in 1956. Thirteen years later, this library was built at 222 East University Avenue. Still it did not provide enough space for the growing city. The public library serving Gainesville today was completed in 1991. The library in this photograph now serves as an annex for city hall. (Courtesy Florida State Archives.)

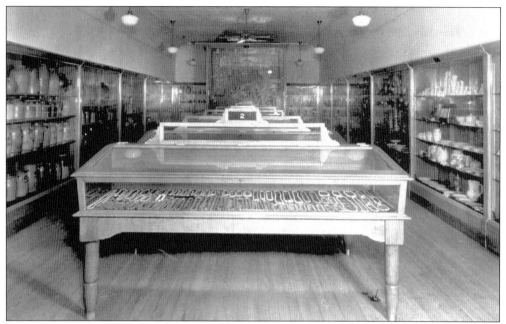

Gainesville also has a collection of renowned museums. When the university opened in Gainesville, a collection of artifacts was moved from the college in Lake City to the new school. Thomas Hall displayed these, but the collection continued to grow and was moved to Flint Hall, as seen here. The collection soon became officially recognized by the state as a museum and moved into the Seagle Building. Finally, in 1970, what is now the Florida Museum of Natural History moved into its present location on Museum Road. (Courtesy University Archives, Department of Special and Area Studies Collections, George A. Smathers Libraries, University of Florida.)

In addition to new buildings being constructed on campus, infrastructure such as roads needed to be built. This is a view from the 1920s of what is now Stadium Road before it was paved. (Courtesy University Archives, Department of Special and Area Studies Collections, George A. Smathers Libraries, University of Florida.)

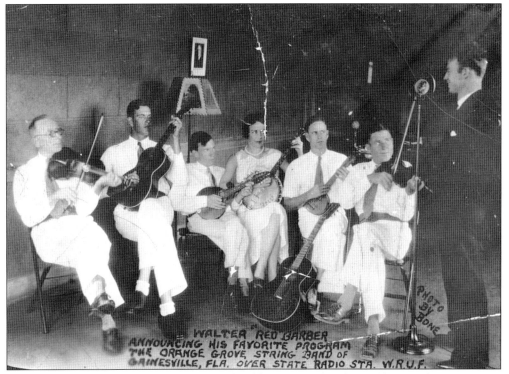

With so many in "The Gator Nation," the school has seen its fair share of famous alumni. Among those is famed Brooklyn Dodgers announcer Red Barber, seen here on the right with the Orange Grove String Band performing for the university radio station, WRUF. Other famous alumni represent politics, academia, entertainment, business, and athletics. (Courtesy Florida State Archives.)

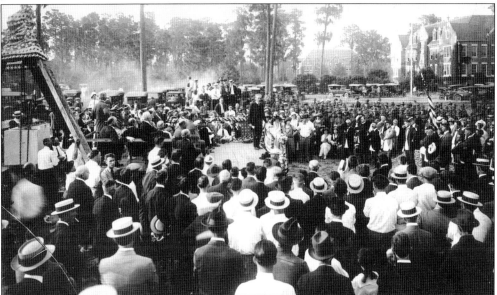

The school has also drawn the noteworthy who were not alumni. Florida governor Cary Hardee drew this crowd in Gainesville in the 1920s. Hardee is seen on the platform in the middle of the throng. The crowd on the right is largely made up of men in uniform. (Courtesy Florida State Archives.)

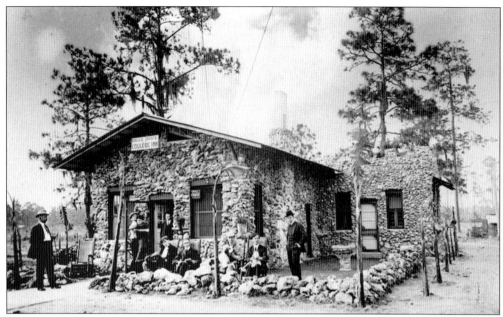

The visitors the University of Florida brought to town needed a place to stay. Uncle Dud's College Inn was the first commercial enterprise that catered to the university and the first to open in its proximity on University Avenue. Uncle Dud's also served as something of a convenience store, selling things like toiletries and alcohol. (Courtesy University Archives, Department of Special and Area Studies Collections, George A. Smathers Libraries, University of Florida.)

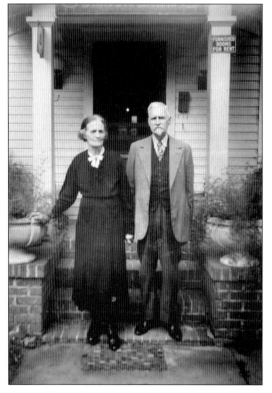

For those looking for more permanent accommodations, there were homeowners in town who offered a room to rent. Such was the case with this local couple in the 1910s. The partially visible sign above the door says Shadow Lawn, which is a Gainesville neighborhood off Northwest Thirty-ninth Avenue. (Courtesy Elmer Harvey Bone Photographic Collection, University Archives, Department of Special and Area Studies Collections, George A. Smathers Libraries, University of Florida.)

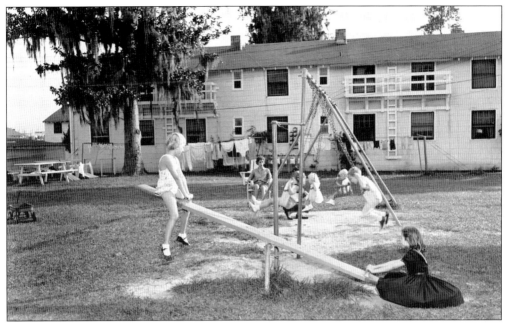

After World War II, Gainesville and the university saw an influx of families looking to take advantage of the GI Bill. These young veterans also needed a place a stay, so 100 housing units from the military and Federal Public Housing Authority were brought in. The homes were placed into units called the Flavet Villages—short for Florida Veterans. The Flavet Villages were torn down in the 1970s, but the field near the center of campus where some of the homes were located still bears that name. (Courtesy University Archives, Department of Special and Area Studies Collections, George A. Smathers Libraries, University of Florida.)

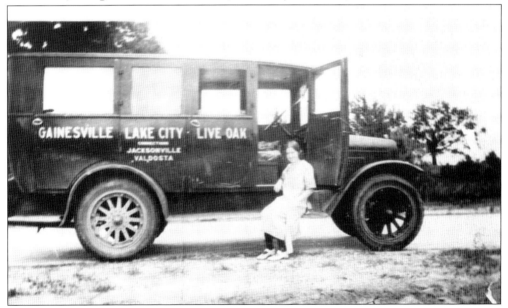

An increased population also called for more forms of transportation. This bus shuttled passengers back and forth between Gainesville, Lake City, Live Oak, Jacksonville, and Valdosta in the 1920s. (Courtesy Florida State Archives.)

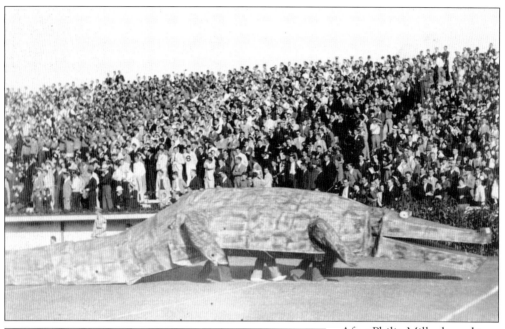

After Philip Miller brought the gator emblem to Gainesville, it quickly came to be the primary identifier of the athletic program. Several different versions of Albert the Alligator have been used over the years, including a wooden version from the late 1930s seen above. In 1957, the school acquired a live alligator that lived in a pen between University Auditorium and the Plaza of the Americas. Through the 1960s, several different live alligators served as Albert before a costumed version was introduced in 1970. In the lower photograph, one of the live Alberts (a smaller one) is used in a prank on a sleeping student in a university dorm. (Courtesy University Archives, Department of Special and Area Studies Collections, George A. Smathers Libraries, University of Florida.)

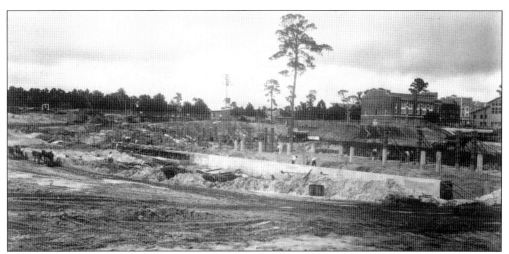

Today the university's athletic program is recognized as being competitive in all sports. However, it is probably best known for the football program. Original construction on what has evolved into the building most commonly called "The Swamp" was completed in 1930. The football stadium was built in a natural depression and most of the 21,769 initial seats were below ground level. A scene from the construction site is seen here. (Courtesy University Archives, Department of Special and Area Studies Collections, George A. Smathers Libraries, University of Florida.)

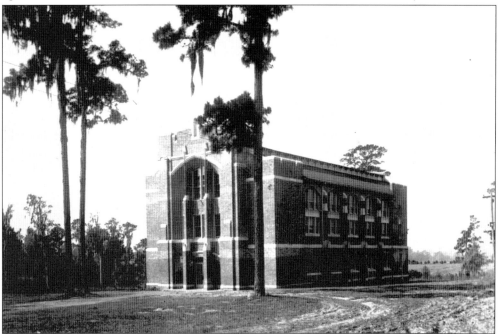

This building is known commonly as Women's Gym and formally as Ustler Hall. The City of Gainesville chipped in funds for its construction in 1918 in order to entice the New York Giants, a Major League Baseball team, to hold their spring training in town. The plan worked, and the Giants even played the Gator baseball team. After that, the building was used for basketball games, dances, and other physical activities. When the school went coed, it was used for the women's athletic program. (Courtesy University Archives, Department of Special and Area Studies Collections, George A. Smathers Libraries, University of Florida.)

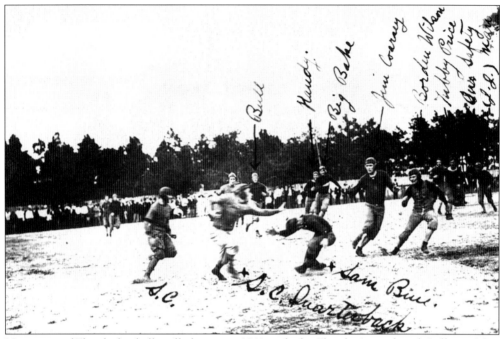

University of Florida football really began in 1901 with the Florida Agricultural College. After the move to Gainesville, the school played its games at Fleming Field before construction of the stadium. A photograph from an early game at Fleming Field against the University of South Carolina is seen here. (Courtesy University Archives, Department of Special and Area Studies Collections, George A. Smathers Libraries, University of Florida.)

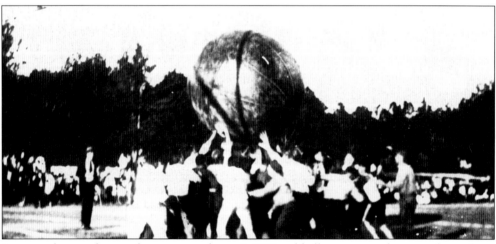

Intramurals were also popular among students. A 1919 pushball tournament between the students of Thomas and Buckman Hall is seen here. Pushball consists of 11-player teams pushing a 6-foot ball across a large field into goals. (Courtesy Florida State Archives.)

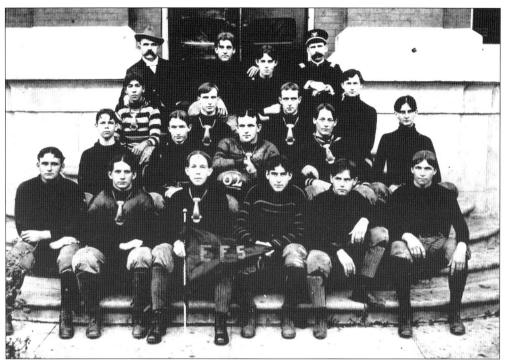

Sports, especially football, were popular throughout Gainesville. The 1902 East Florida Seminary team is pictured here. Team members are unidentified. (Courtesy University Archives, Department of Special and Area Studies Collections, George A. Smathers Libraries, University of Florida.)

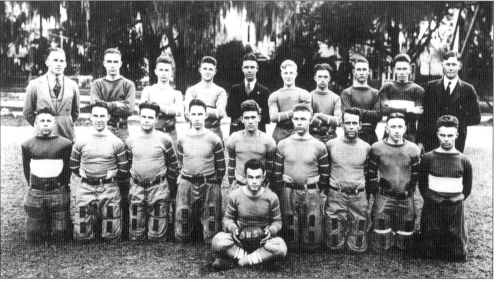

Gainesville High School also had a football team. The 1920 squad is pictured here. From left to right, team members included (seated) Talmadge Vansickle; (kneeling) Joe Perry, Devoux Vrooman, Ralph Eads, Philip Vrooman, Erskin Parks, Rutledge Emerson, Clifford Blitch, Barco Bishop, and Hayward Davis; (standing) Rex Farrior, Julian Ballentine, Donald Bishop, Andrew Ludwig, Gardner Welch, John A. H. Murphree, Ed Swearingen, Mondell Cellon, Carlos Zetrouer, and Fritz Buchholz. (Courtesy Florida State Archives.)

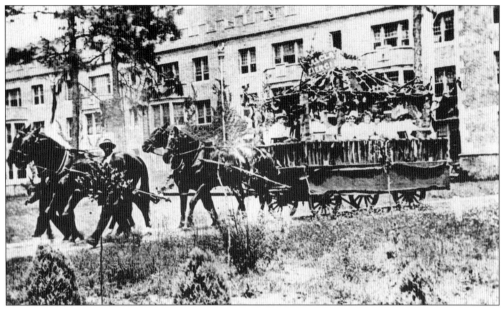

The various schools in Gainesville have always been important to the town and provided citizens reasons to celebrate. This photograph was taken in the 1910s as students from Gainesville High School paraded past the university on Class Exercise Day. (Courtesy Florida State Archives.)

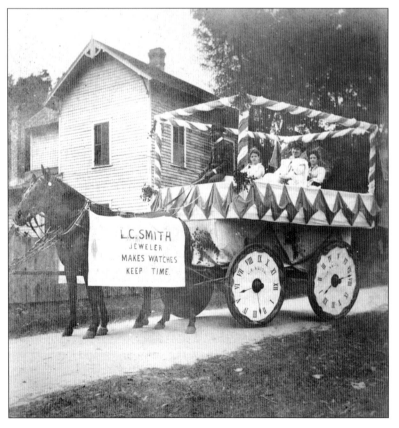

Over the years, businesses have used such parades to advertise. Such was the case with this float that advertised watches sold from L. C. Smith's Jewelry shop. Note the wheels of the coach that have been decorated to look like clocks. (Courtesy P. K. Yonge Library of Florida History, Department of Special and Area Studies Collections, George A. Smathers Libraries, University of Florida.)

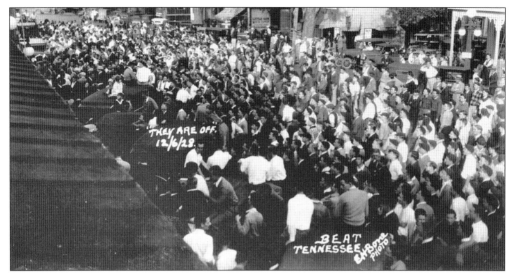

Pep rallies that brought students and citizens out to support the Gators were popular in anticipation of big football games. A pep rally for the game against Tennessee on December 6, 1928, drew this crowd. Unfortunately, the Gators lost the game 12-13. (Courtesy Elmer Harvey Bone Photographic Collection, University Archives, Department of Special and Area Studies Collections, George A. Smathers Libraries, University of Florida.)

The University of Florida homecoming parade is generally the city's largest and most popular annual parade. It usually features a theme. For the 1958 parade, the brothers of Delta Upsilon created a Viking ship with a gator head that moved down University Avenue. (Courtesy University Archives, Department of Special and Area Studies Collections, George A. Smathers Libraries, University of Florida.)

Over the years, Gainesville has grown from a sleepy little town started as hardly more than a train depot to one of the better-known cities in the state. These two images illustrate how quickly the town grew after the University of Florida's arrival. The photographs were taken from nearly the same location. Both look west along West University Avenue from between Second Street and First Street. The 1890 First Presbyterian Church is seen on the right in the upper photograph along with a horse cart. In the lower photograph, horses were replaced by horsepower in a bustling downtown Gainesville about 50 years later. (Courtesy P. K. Yonge Library of Florida History, Department of Special and Area Studies Collections, George A. Smathers Libraries, University of Florida.)

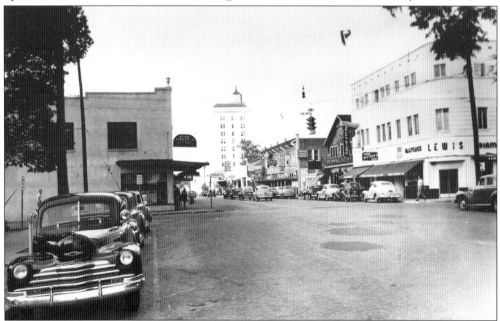

BIBLIOGRAPHY

www.gatorzone.com
www.gra-gnv.com/index.php
www.hailehomestead.org
heritage.acld.lib.fl.us/
Hildreth, Charles H., and Merlin G. Cox. *History of Gainesville, Florida, 1854–1979*. Gainesville, FL: Alachua County Historical Society, 1981.
www.mathesonmuseum.org
McCarthy, Kevin M. and Murray D. Laurie. *Guide to the University of Florida and Gainesville*. Sarasota, FL: Pineapple Press, 1997.
www.president.ufl.edu
Rajtar, Steve. *A Guide to Historic Gainesville*. Charleston, SC: The History Press, 2007.
web.uflib.ufl.edu/spec/pkyonge/index.html

ACROSS AMERICA, PEOPLE ARE DISCOVERING
SOMETHING WONDERFUL. *THEIR HERITAGE.*

Arcadia Publishing is the leading local history publisher in the United States. With more than 4,000 titles in print and hundreds of new titles released every year, Arcadia has extensive specialized experience chronicling the history of communities and celebrating America's hidden stories, bringing to life the people, places, and events from the past. To discover the history of other communities across the nation, please visit:

www.arcadiapublishing.com

Customized search tools allow you to find regional history books about the town where you grew up, the cities where your friends and family live, the town where your parents met, or even that retirement spot you've been dreaming about.